IMAGES of America
SAWTELLE
WEST LOS ANGELES'S JAPANTOWN

Dr. Jack Fujimoto is the author and chronicler of *Sawtelle: West Los Angeles's Japantown*. (Courtesy Grace Fujimoto.)

ON THE COVER: Japanese classical dance performers are at the Japanese Institute of Sawtelle (JIS) as part of an entertainment program in the 1930s. Pictured, from left to right, are (first row) Yukiye Teshiba, Masako Kato, Fusaye Uyeno, Yoshino Jeniye, Yoshiko Ota; (second row) Mrs. Kato, Sachiko Nakata, Mrs. Iyo Nakata, Miyoko Watanabe, Haruko Nakata; (third row) Mrs. Teshiba, Mrs. Watanabe, unidentified, Mrs. Uyeno, Mrs. Kageyama, Mrs. Jeniye, Mrs. Ota. (Courtesy Haruko Nakata.)

IMAGES of America
SAWTELLE
WEST LOS ANGELES'S JAPANTOWN

Jack Fujimoto, Ph.D.,
the Japanese Institute of Sawtelle,
and the Japanese American Historical Society
of Southern California

ARCADIA
PUBLISHING

Copyright © 2007 by Jack Fujimoto, Ph.D.
ISBN 978-0-7385-4797-8

Published by Arcadia Publishing
Charleston, South Carolina

Printed in the United States of America

Library of Congress Catalog Card Number: 2007925820

For all general information contact Arcadia Publishing at:
Telephone 843-853-2070
Fax 843-853-0044
E-mail sales@arcadiapublishing.com
For customer service and orders:
Toll-Free 1-888-313-2665

Visit us on the Internet at www.arcadiapublishing.com

This book is dedicated to my wife, Grace Toya Fujimoto, and her family, who gave me large doses of support and encouragement, and our family of Crystal, Randy, Jolene, and Maya, as well as Gerald and Stuart, and our grandchildren of Matthew, Jaxon, and Hailey. Further, this book is dedicated to my parents, Morizo and Emi Fujimoto, and my siblings, who permitted me to pursue my academic interests. This book is also dedicated to the Boards of
Japanese Institute of Sawtelle and
Japanese American Historical Society of Southern California
for their approval and encouragement.

CONTENTS

Acknowledgments		6
Introduction		7
1.	The Issei Period: Pre-1942	9
2.	The Nisei Era: Resettlement and Entrepreneurship	25
3.	Tom Ikkanda, Community Leader	57
4.	Social, Institutional, and Recreational Life	87
5.	The Changing Face of Sawtelle's Japantown	119
Bibliography		127

Acknowledgments

In this publication, which is self-directed, it is most difficult to recognize and thank all who have provided advice, photographs, and information about Sawtelle's Japantown, a special community in West Los Angeles.

Primary sources are Joe Nagano, Tom and Dorothy Ikkanda, George Oshimo, Jean Ushijima, Sid Yamazaki, Bay Cities Gardeners' Association through Shinkichi Koyama, Grace Toya Fujimoto, and Yoshinori Kubota. Secondary sources are Mary Ota Sata, Toshio and Masako Ishioka, George Toya, Don Sakai, Meriko Hoshiyama Mori, Eiko Iwata, Arnold Maeda, Randy Sakamoto, Yuki Sakurai, Scott Fujimoto, Ida Kaisaki, and Kimi Ishii.

Special tribute is extended to my wife of 50 years, Grace, for her support and encouragement of this publication. Through this book and images, Grace will be able to document portions of her life in Sawtelle after her World War II concentration camp experience.

Special thanks are extended to Dale Sato and Iku Kiriyama for discussing this project in conjunction with their desire to document their versions of the Japanese experience in California.

Any shortcomings or errors of omission, commission, and attribution are solely the responsibility of the author.

—Jack Fujimoto, Ph.D.

INTRODUCTION

When people mention Japantown in West Los Angeles, they usually think of Sawtelle. The immigrant Japanese (*Issei*) pronounced Sawtelle as "soh te ru," and at times, Sawtelle was found on walls graffitied as "sotel." Sawtelle Boulevard between Santa Monica and Pico Boulevards was and is the hub of Japantown.

At the beginning of the 20th century, Issei settled in the Sawtelle area, where farming took place in open fields south of Pico Boulevard, and gardening jobs were plentiful north of Santa Monica Boulevard. The farmers relied on large families to provide the necessary labor for labor-intensive work in the barley and celery fields. The many Issei gardeners found themselves in need of plants and shrubs, which they, in turn, found in Issei-established nurseries. Sawtelle was a Japantown where Issei supported each other in an isolated community and therefore lived in a ghetto of Issei and their families.

More recently, Sawtelle's Japantown has often been called "Little Osaka" in contrast to "Little Tokyo" because of Sawtelle's many colorful eateries and shops.

During the past century, the flavor of the Sawtelle community has changed through distinct phases, mainly because of a convergence of an aging Issei population, a cutback in their landscaping and gardening business, and an inflow of new cultural and racial ethnicities to Sawtelle Boulevard.

From the 1900s through the 1930s, the Issei developed a distinct Japantown in Sawtelle where close cultural ties and a stable family life contributed to a community where the Issei families patronized Japanese shops. A stable family life included large families, some with a half a dozen or more children.

Sawtelle was a tranquil community. A common scene might be one where the Issei would sit on the porch enjoying the cool ocean breeze sipping liquor, often home-brewed. This was common after having worked hard during the day. Often the Issei family went to Sawtelle Boulevard to patronize Japanese shops where Japanese was the spoken language. Even then, the traffic on Sawtelle Boulevard was an issue, which still persists into the 21st century.

The Issei, in general, did not learn the English language. They did not read newspapers. Their ethic was to work hard to support their family and provide education for their children. The tie that bound the Issei family to others was the community center in Sawtelle, located at 2110 Corinth Avenue. This Japanese community center provided Japanese language instruction and social exchanges as well as entertainment for the Issei family. The Sawtelle community center was incorporated in 1929 as the Japanese Institute of Sawtelle.

The Issei were primarily laborers in the fields of grains and vegetables south of Pico Boulevard or gardening and landscaping trades in Westwood, Bel Air, and Brentwood, north and east of Sawtelle's Japantown. For many, because of hardships created by a hostile environment and lack of job opportunities, the Issei wanted to earn enough capital so that they could return to Japan. Many of their children, called *Nisei*, they were sent by Issei parents for an education in Japan. When they returned, they were called *Kibei*, meaning "returning to the USA."

World War II disrupted the tranquil Sawtelle Japantown. Evacuation orders by the federal government required that all Japanese leave Sawtelle without due process or time to negotiate any disposal of property.

Many Japanese were incarcerated as inmates at Manzanar (near Mount Whitney of the Sierra Nevada). Others were sent to the famous Santa Anita Race Track, living in horse stalls, and later transported to concentration camps in Arkansas (Rohwer and Jerome).

The Sawtelle Issei and their offspring joined the mass exodus of 120,000 who were sent to the 10 concentration camps set up by the War Relocation Authority during World War II. From the camps, many former Sawtelle residents took jobs elsewhere in the United States. Many settled in the Chicago and Minneapolis areas.

In the postwar Sawtelle, a new Japantown was born and flourished. Many of the prewar Issei returned to establish residence in Sawtelle again. Some returned to homes that they left entrusted to others only to learn that all was gone. Others were newcomers who frequented the several hostels, including the Japanese Institute of Sawtelle and the eight boardinghouses in Sawtelle. A severe housing shortage called for developers and builders to provide more houses. Japanese Americans (commonly called *Nikkei*) bought many of these new single-family and duplex dwellings. Generally the Nikkei houses could be distinguished from other houses on the street by their distinctive Japanese gardens.

As property values increased, many Nikkei started converting their valuable property to apartments. With the aging Issei continuing to live in Sawtelle, their offspring, the Nisei, sought college and job opportunities elsewhere. In 1952, the Issei could apply for naturalized citizenship to become Americans. This opened the door for many of the Issei. The prewar civil service jobs that were not open to Japanese were now available. The Nisei became professionals, having jobs in the fields of medicine, law, education, accountancy, chemistry, and others.

Sawtelle had 150 Nikkei establishments in the immediate postwar period supported by an estimated 6,000 Nikkei population. Just to give an indication of the dynamics of the Japantown of that early postwar period, there were three barbershops staffed by two to three barbers each. Today there are none.

From the 1970s, there has been a new generation of Issei in Japantown. They are merchants and professionals who do not necessarily reside in Sawtelle but provide the services that make Sawtelle deserve the nickname Little Osaka. There are also some Nikkei descendants of the first Issei immigrants returning to Sawtelle to retain its Japantown flavor. The transformation of West Los Angeles's Japantown continues to show its traditional Japanese roots on a smaller scale, with newcomers upholding the cooperative spirit of the Issei immigrant pioneers.

One

THE ISSEI PERIOD
PRE-1942

The Issei period from 1900 to 1942 featured a strong Japanese instinct for survival in a hostile environment where opportunities were limited.

Several years ago, in the research to write *The Yoneda Story: A Search for Roots*, it was clear to this author that the Issei had several hurdles to scale or bear in order to live, much less thrive, in an environment filled with discrimination.

Land ownership was denied. Property and residential rights were marginally available because of covenants and discriminatory practices. Job opportunities were limited to non-professional and non–civil service work, such as gardening, domestic work, or produce and farm labor. Miscegenation laws ruled. Issei used the "picture bride" (*shashin kekkon*) system to find a mate from Japan. Many tales have been shared about expectations and disappointments in finding marriage partners.

Why was Sawtelle an ideal place for Issei to live?

One story is that Sawtelle was an ideal residential area for Issei because they were denied access to the estate communities of Westwood, Bel Air, and Brentwood. The Issei worked in these areas but were barred from living in them. The opening of the University of California campus in Westwood created more homes requiring landscaping and gardening. Large employers, such as Armacost Nursery, had many Issei employees. But saving money was difficult. Many Issei had commitments to forward funds to Japan. A prevailing desire was to save money to return and live in Japan. Others wanted to send their children, the Nisei, for education in Japan.

Yet the Issei survived during this pre–World War II period by promoting the strong family values of education, community, and religion. Their community center, the Japanese Institute of Sawtelle (JIS), was incorporated in 1929 as a nonprofit corporation for events such as *shibai* (talent shows), *koenkai* (lectures), *shigin* and *minyo* (singing), and *katsudo shashin* (motion pictures).

Many Nisei have spoken about their stubborn Issei parents not wanting to learn English themselves but enrolling them in Sawtelle Gakuin, the Japanese language school. The students were required to spend an hour after public school instruction or a six-hour day on Saturday in class. Students were exposed to proper Japanese etiquette and procedure for bowing to show respect and greetings. Absenteeism in this closed community was virtually nonexistent.

On Sundays, JIS served for a short period as a venue for religious services. Within a short time, the Buddhists found their temple and Methodists established their church, which left JIS to serve the community.

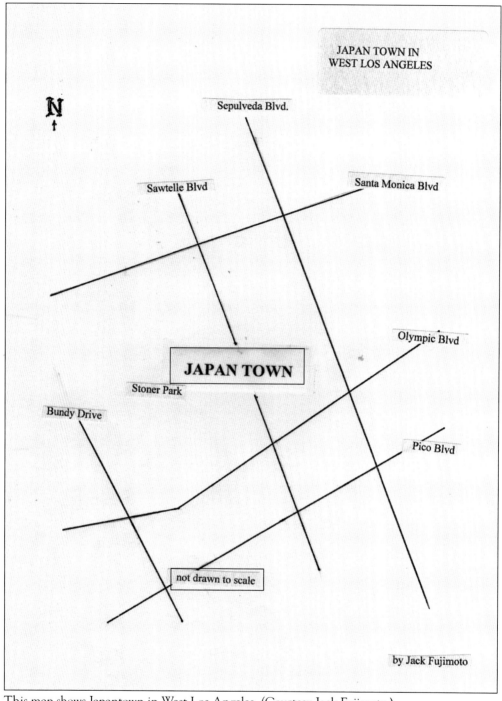

This map shows Japantown in West Los Angeles. (Courtesy Jack Fujimoto.)

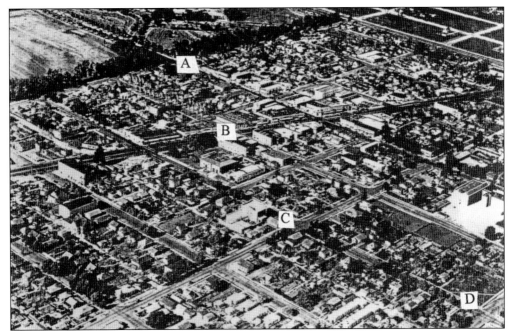

This 1933 aerial photograph shows Japantown in relation to major streets in Sawtelle. Pictured are (A) Sepulveda Boulevard, (B) Santa Monica Boulevard, (C) Sawtelle Boulevard and Sawtelle Boulevard School (later renamed Nora Sterry Elementary School), and (D) Japantown. (Courtesy Joe Nagano.)

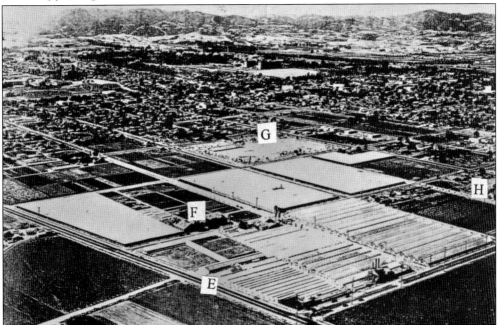

This 1930 aerial photograph shows a section west of Sawtelle's Japantown. Armacost Nursery was a large employer of the Issei. This image shows (E) Bundy Drive, (F) Armacost Nursery, (G) Stoner Park (where a swimming pool was available and used by Issei and their children), and (H) Japantown. (Courtesy Joe Nagano.)

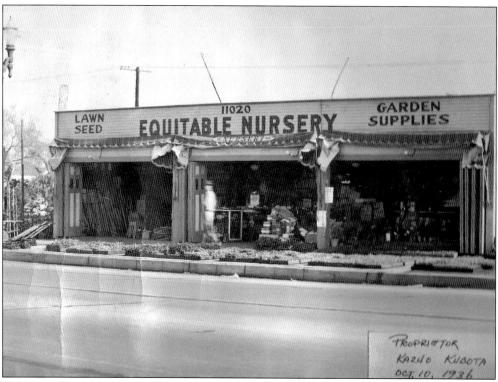

This photograph shows the Kazuo Kubota–owned Equitable Nursery in 1936. This full-scale nursery sold plants, push mowers, and fertilizers. The nursery occupied a full block at 11020 Olympic Boulevard. (Courtesy Joe Nagano.)

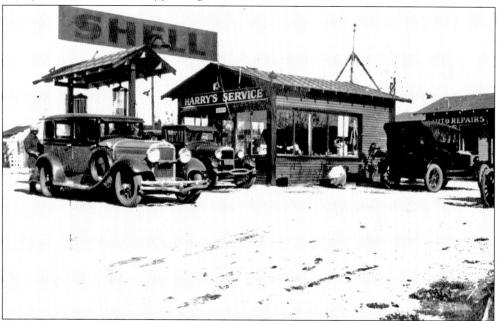

In the 1930s, Harry's Shell Service Station was located at 2004 Sawtelle Boulevard in Japantown. The proprietor was Harry Koga. (Courtesy Tom Ikkanda.)

In pre-1942 Sawtelle's Japantown, Japanese classical dance was highly entertaining. Iyo Nakata (left) is standing next to Miyoko Watanabe, a talented Japanese classical dancer who performed frequently in Sawtelle's Japantown. (Courtesy Joe Nagano, Mary Sata, and Haruko Nakata.)

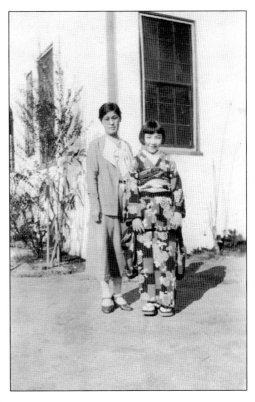

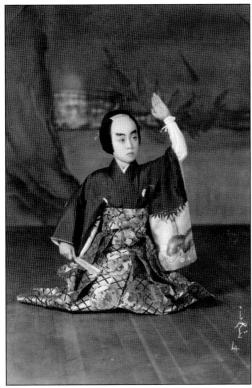

The Japanese Institute of Sawtelle (JIS) was often the center of entertainment for the Issei community. Yukiye Teshiba performed at the JIS in the 1930s for their numerous shows. (Courtesy Joe Nagano and Mary Sata.)

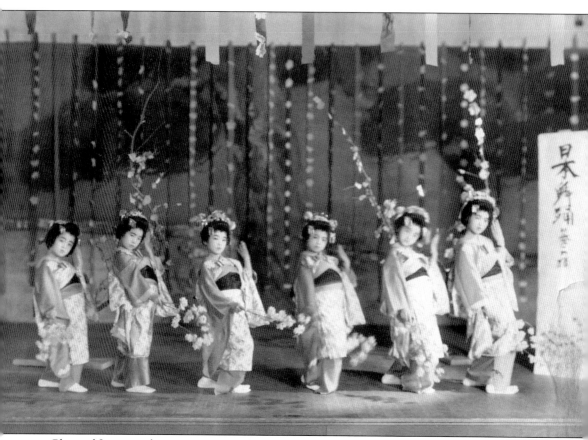

Classical Japanese dancers participated in a spring 1932 entertainment program at the Sawtelle Gakuin, the Japanese language school at JIS. From left to right are Yukiye Teshiba, Masako Kato, Fusaye Uyeno, Yoshino Jeniye, Yoshiko Ota, and Fumi Kato. (Courtesy Joe Nagano and Mary Sata.)

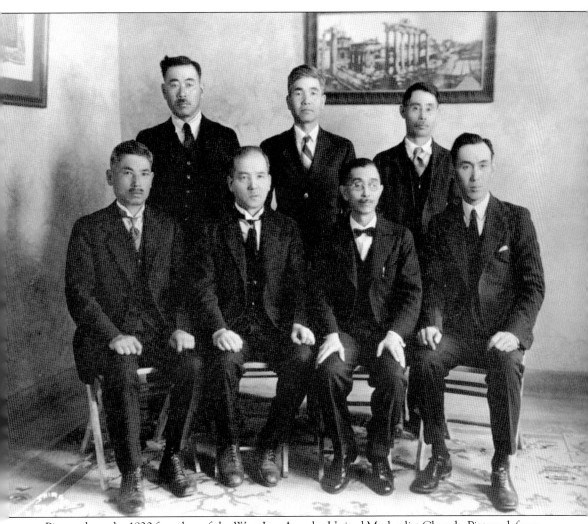

Pictured are the 1930 founders of the West Los Angeles United Methodist Church. Pictured, from left to right, are (first row) unidentified, Gisuke Sakamoto, Rev. Soh, and Mr. Ichiki; (second row) unidentified, Mr. Nagayama, and Mr. Yagi. (Courtesy Randy Sakamoto and Haruko Nakata.)

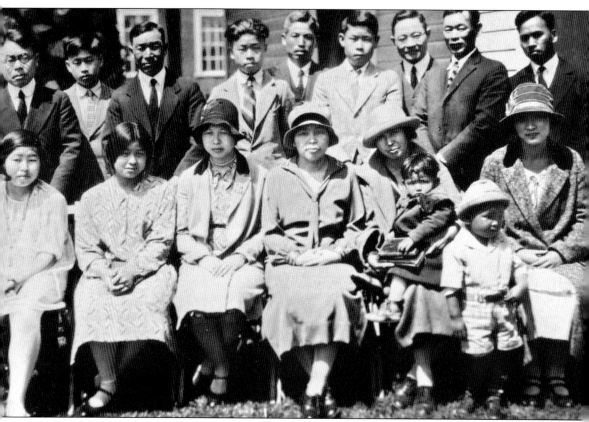

This 1941 photograph shows some members of the Japanese Reformed Church, located at Massachusetts Avenue and Cotner Street in Sawtelle. With the advent of World War II and evacuation to Manzanar wartime relocation camp for Issei and Japanese Americans, the church closed its doors, not to reopen again. Some members, after the close of camps, eventually gravitated to join Rev. David Unoura at the West Adams Christian Church. Pictured from left to right are (first row) Kazuko Suzuki, ? Mizoe, ? Mizoe, ? Suzuki, ? Odahara (with unidentified child in lap), unidentified child, and ? Kitagawa; (second row) Rev. ? Suzuki (leader), Hiroshi Suzuki, Sanezumi Nagano, Tom Suzuki, unidentified, Paul Mitsuye, ? Kitagawa, ? Odahara, and unidentified. (Courtesy Joe Nagano.)

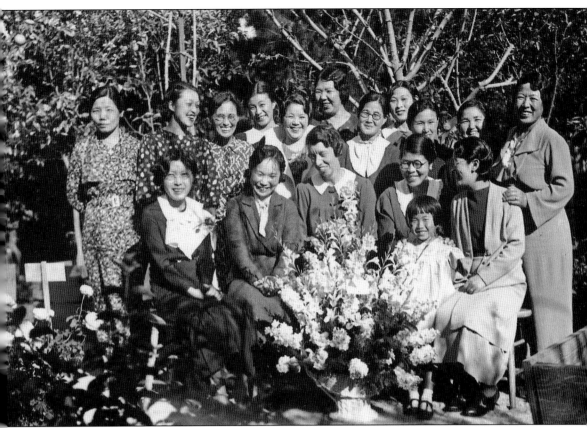

Celebrating Mother's Day in 1932 were members of the West Los Angeles United Methodist Church congregation. Pictured, from left to right, are (first row) Chieko Sakamoto, unidentified, Mrs. Roberts, unidentified, Iyo Nakata, and Mary Honda; (second row) Mrs. Jeniye, Mrs. Nakahama, unidentified, unidentified, Mrs. Nitta, Mrs. Asoka, Mrs. Taka Honda, Tomiko Hashimoto, unidentified, Mrs. Watanabe, and Mrs. Michiko Hashimoto. (Courtesy Randy Sakamoto and Haruko Nakata.)

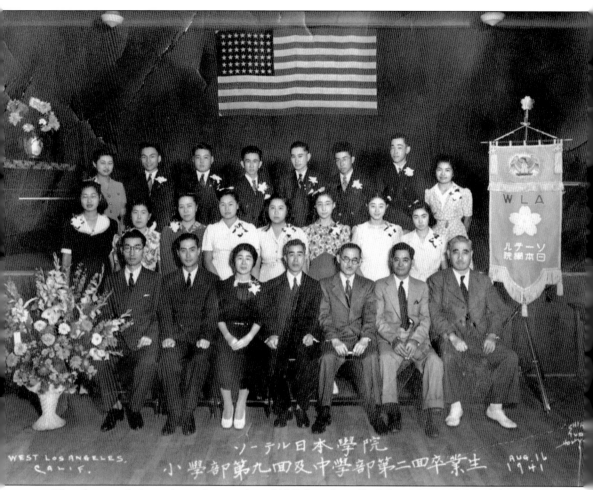

This photograph shows the graduating class of 1940 from Sawtelle Gakuin. Pictured, from left to right, are (first row) unidentified teacher, Masao Hayashi, Fuki Hoshiyama, Masaharu Oba, unidentified, unidentified, and Dr. Nitta; (second row) Meriko Hoshiyama (Mori), Hisako Sakioka, ? Shijoh, Meiko Mikama, Jean Araishi ?, Tamaru Shijoh, Helen Shimizu, and Fumi Yotsukura (Tsuruda); (third row) Sachiko Nakata Ota, unidentified, Ujinobu Niwa, Tom Tokuda, Mas Hayashida, unidentified, ? Matsuuchi, and Helen Tamaki. Fuki Hoshiyama, the only female teaching in a society where males dominated, started teaching at Sawtelle Gakuin in 1927 and became its principal in 1954, retiring after 46 years of service. (Courtesy Randy Sakamoto.)

This is a sample elementary school grammar textbook for the upper-level second-grade students at Sawtelle Gakuin. During the pre-1942 period, Japanese language textbooks followed the curriculum established by the Japanese Ministry of Education. (Courtesy Jack Fujimoto.)

This is a sample extracurricular reader for Japanese language students at Sawtelle Gakuin. (Courtesy Jack Fujimoto.)

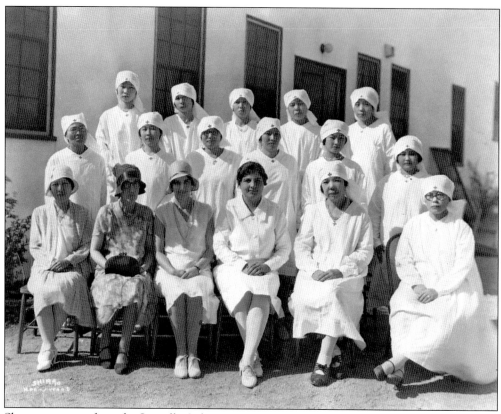
Shown is a group from the Sawtelle Gakuin Women's Group (Fujin Kai) who are taking a first-aid course. (Courtesy Joe Nagano and Mary Sata.)

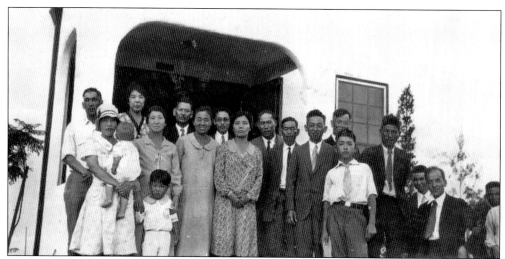
This 1929 group photograph shows officials, staff, and the first class of students at Sawtelle Gakuin. Gisuke Sakamoto, founder of the Japanese language school, and Kenso Ikkanda, treasurer, were among the officials pictured. (Courtesy Tom Ikkanda.)

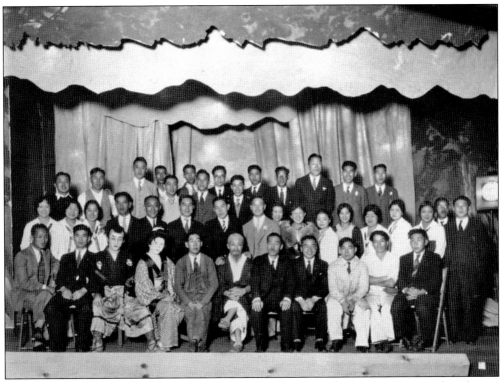
This group photograph shows entertainers at a special program for youth group members (*seinen kai*) of the Los Angeles Buddhist Temple branch in West Los Angeles. This photograph is dated April 6, 1931. (Courtesy George Oshimo.)

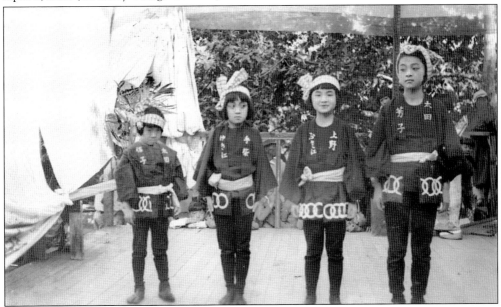
Young Japanese students performed at one of the annual community picnics in West Los Angeles. Pictured from left to right are Nobuko Ota, Yukiye Teshiba, Fusaye Uyeno, and Yoshiko Ota. (Courtesy Joe Nagano and Mary Sata.)

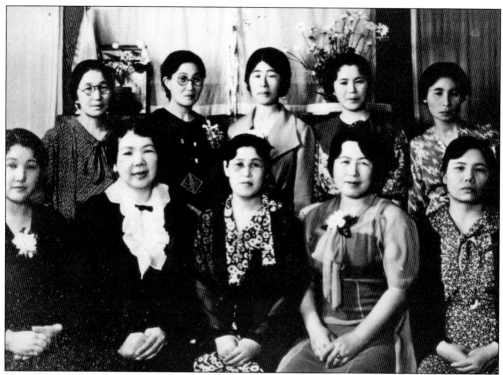

This 1930s photograph shows the Sawtelle Gakuin Women's Group (Fujin Kai). Pictured, from left to right, are (first row) Haruko Niwa, Mrs. Asoka, Iyo Nakata, Michiko Hashimoto, Mrs. Jeniye; (second row) Mrs. Sakamoto, Taki Honda, Fuki Hoshiyama, Katsuko Nitta, Mrs. Nagayama. (Courtesy Joe Nagano and Haruko Nakata.)

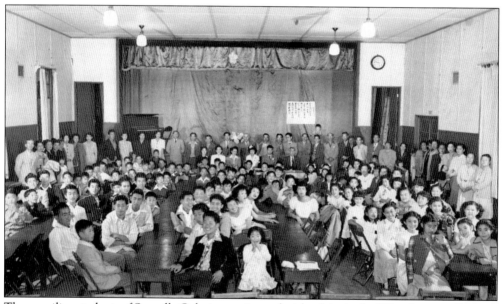

These smiling students of Sawtelle Gakuin are pictured with adults in the JIS auditorium (*kaikan*). (Courtesy Grace Fujimoto.)

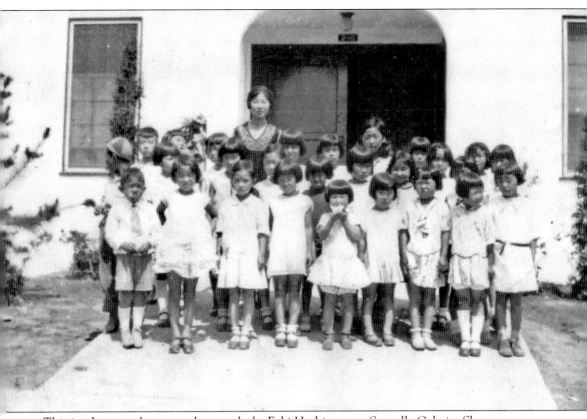

This is a Japanese language class taught by Fuki Hoshiyama at Sawtelle Gakuin. She was a very influential person who guided students in the high moral standards of the Japanese people. Her daughter Meriko Mori stated that Hoshiyama Sensei (teacher) practiced the following guiding principles: *jin* (tolerance), *gi* (honor), *rei* (respect), *chi* (knowledge), and *shin* (faith). Meriko grew up with these principles while attending Sawtelle Gakuin and later as a student at University of California at Los Angeles (UCLA). When the mandatory evacuation order came in 1942, Meriko was dismissed from UCLA, but after World War II, she returned to get her baccalaureate degree in nutrition. (Courtesy Joe Nagano and Meriko Hoshiyama Mori.)

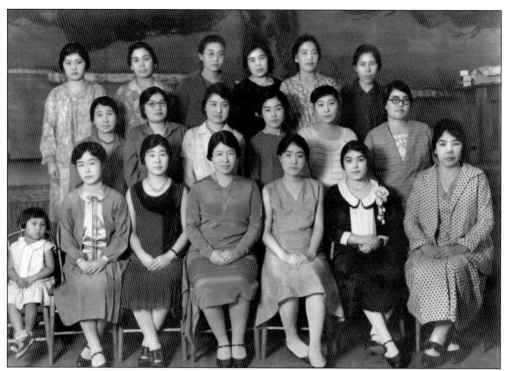

This is a December 8, 1929, photograph of the Sawtelle Gakuin Women's Group (Fujin Kai). The women were an integral part of running the school, while the males were entrusted with leadership roles. Setting up the different events for the Gakuin curriculum such as Field Day athletic events, the picnics, the talent shows, and many other events involved the women of the Fujin Kai. They were the backbone of the school and kept Sawtelle Gakuin going. (Courtesy Joe Nagano and Meriko Hoshiyama Mori.)

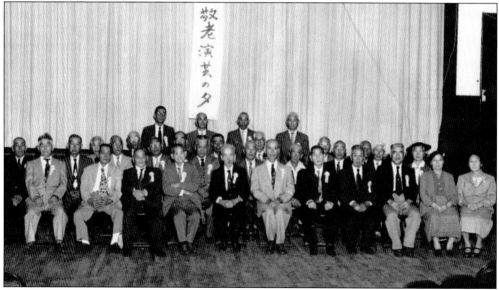

This 1930s group photograph shows seniors being treated with respect through an entertainment program. (Courtesy Joe Nagano and Mary Sata.)

Two

THE NISEI ERA
RESETTLEMENT AND ENTREPRENEURSHIP

In contrast to the pre–World War II period's Issei experience, the postwar period is often called the *Nisei* experience. The Nisei are the offspring of the Issei.

The mass exodus to America's wartime concentration camps for Issei and Japanese Americans, the Nikkei, occurred in 1942. With the war's end in 1945, the so-called "resettlement years" began for many of the original residents of Sawtelle. Those fortunate to have bought property before the war returned to it. However, many were denied property rights unless they could buy property in the name of their children or could buy property after they became naturalized through the 1952 McCarren Walter Act legislation.

The Japanese Institute of Sawtelle (JIS), Japantown's community center, was entrusted to the American Red Cross. Other community centers such as the Buddhist temple and Methodist church were entrusted to overseers. From early 1942 to late 1945, when the concentration camps closed, families found their own ways of entrusting others as caretakers. Many were disappointed when they returned to Sawtelle to find their storage inventory ransacked.

The JIS was returned in 1945 and used as a hostel to greet Issei and Nikkei relocating to Sawtelle. Space was limited, and newcomers were sent to boardinghouses, such as Kobayakawa Boarding House on Sawtelle Boulevard and Ota House on Federal Avenue. Many Nikkei opened small shops, markets, nurseries, eateries, and services that catered to Japantown immigrants and the Nikkei. Residents in Westwood, Beverly Hills, and Bel Air employed Japanese gardeners and landscapers. Nurseries, garden equipment sales and repairs, packaged lunches, and personal services flourished. The Nikkei nurseries dominated Sawtelle because of the jobs for gardeners. Restrictive city covenants prevented Nikkei from buying homes in the affluent Westside, but these homes were where many Nikkei gardeners worked.

Hobbies such as cultivating miniature trees (bonsai), flower arranging (ikebana), and classical writing (*shodo*) expanded. *Sushi* became a favorite food on Sawtelle Boulevard along with several *udon* and ramen eateries. The resettlement years of 1945 to 1965 allowed Sawtelle Nikkei to grow Japantown. It became Little Osaka, a place of fine, fast, delicious foods mixed with traditional service, including friendly greetings with a bow and shouts of "welcome" (*irrashai mase*).

More recently, the Nisei aspect of enterprising Nikkei merchants started to decline because the *Sansei* and *Yonsei* generations, the third and fourth, received good educations and pursued careers elsewhere.

The Japanese Institute of Sawtelle is located at 2110 Corinth Avenue in Sawtelle's Japantown. Since its incorporation in 1929, the institute has served as a venue for Issei and Nikkei activities in West Los Angeles. One of its principal purposes is the teaching of Japanese language through its Sawtelle Gakuin, an independent subsidiary of the nonprofit JIS. Through reorganization in 2000, the student body has grown from 40 students to its 2006 body of 140 students. (Courtesy Jack Fujimoto.)

Pictured is Dr. Jack Fujimoto. He has contributed much to the betterment of Sawtelle's Japantown by reorganizing JIS in 1986 to play a larger role in Nikkei community affairs. He served as JIS president for nine years, on its Coordinating Council for three years, and at the West Los Angeles Buddhist Temple for four years. He also served as a community advisor for Union Bank of California as well as the more recently formed Pacific Commerce Bank. (Courtesy Grace Fujimoto.)

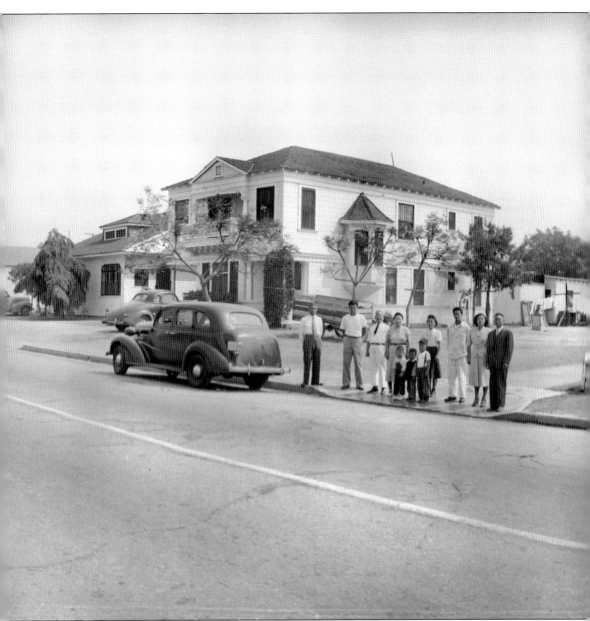

This is a full view of the well-known Kobayakawa Boarding House that provided room and board to singles primarily after World War II. Riichi Ishioka came from Hiroshima, Japan, as an immigrant to San Francisco in 1910. In 1926, Riichi Ishioka bought this property and named the boardinghouse for his father-in-law. Riichi Ishioka was an excellent counselor and teacher who helped guests develop skills as gardeners and landscapers. Through learning the professions better, his boarders were able to do their work better and, in most cases, expand their businesses. He also had a monetary savings system (called *tanomoshi*) where boarders were able to accumulate capital to buy equipment to further their businesses or even place a down payment on a house. (Courtesy Tosh and Masako Ishioka.)

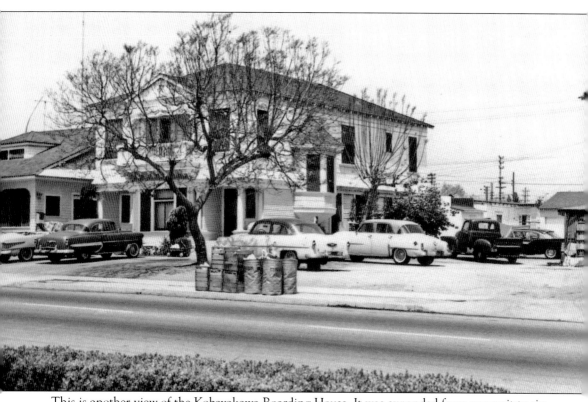

This is another view of the Kobayakawa Boarding House. It was expanded from one unit to six units and cared for 60 boarders at a time. Room and board was less than $40 a month. Lunch even had rice cakes (*onigiri*) for those who wanted bento made. Besides the Ishioka family, Riichi Ishioka employed longtime helpers such as Sugi Kiriyama, Koyoshi Sasaki, and a Mrs. Maeda, the former two women staying with him until he closed in 1979. Each of the Issei women had sons who were highly influential in Nikkei circles. George Kiriyama became a member of the Board of Education of the Los Angeles Unified School District, second largest in the United States. Masao Sasaki became president of the West Los Angeles Buddhist Temple for several years. Dr. Tom Maeda became a medical practitioner who frequently returned to Sawtelle's Japantown. (Courtesy Tosh and Masako Ishioka.)

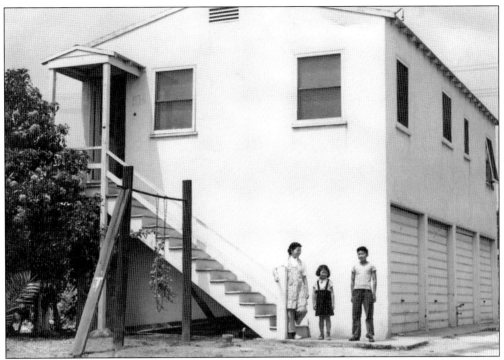

This is a side view of the Ishioka residence. Riichi Ishioka, owner, had three children, who are standing outside of the house—Toshiye (left), Alice (center), and Toshio. (Courtesy Tosh and Masako Ishioka.)

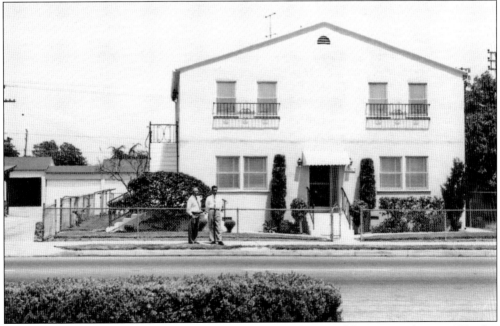

This is the front face of the Ishioka residence. Riichi Ishioka retired from ownership in 1979, after which developers demolished the boarding house in favor of multi-story office suites. He died in 1979. (Courtesy Tosh and Masako Ishioka.)

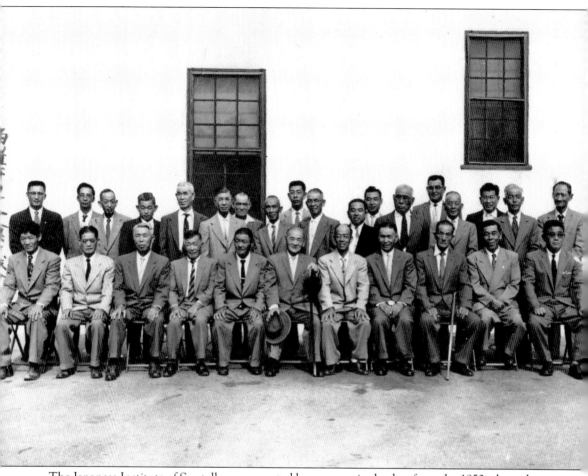

The Japanese Institute of Sawtelle was operated by community leaders from the 1950s through a West Los Angeles Japanese American Coordinating Council (Nishi Rafu Nikkeijin Kyogi Kai). In 1986, a reorganization was initiated and was consummated in the year 2000 with a Japanese-American Community Center established. (Courtesy Yoshinori Kubota.)

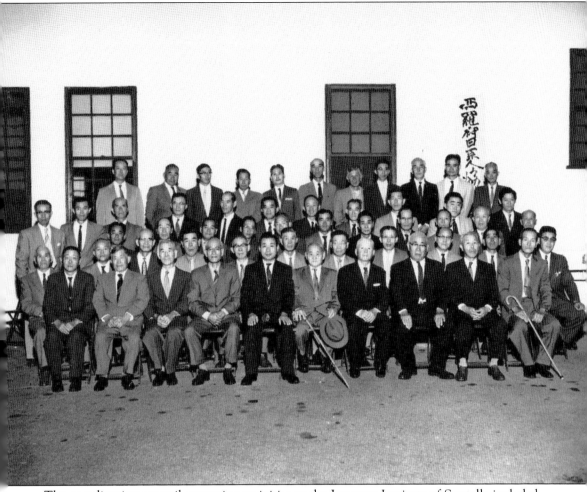

The coordinating council governing activities at the Japanese Institute of Sawtelle included those for the Japanese language school, Sawtelle Gakuin, the martial arts academies, and cultural activities. It was a large responsibility considering that they had no executive and that all were volunteers. This photograph shows the leadership in the 1960s. (Courtesy Yoshinori Kubota.)

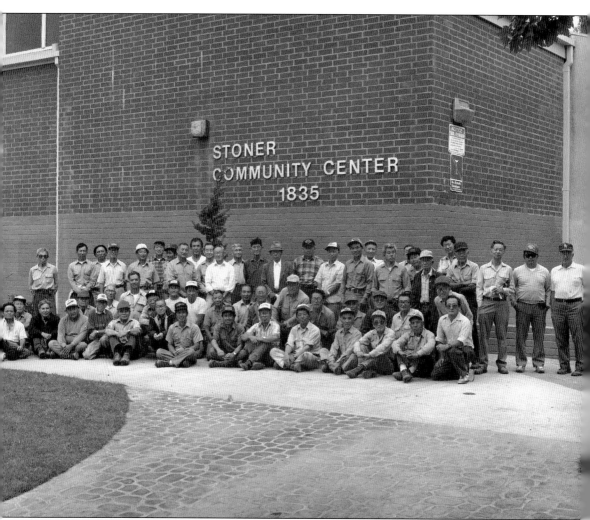

Stoner Community Center is at 1835 Stoner Avenue. Members of the Bay Cities Gardeners' Association (BCGA) voluntarily donated time, materials, and labor toward its beautification, maintenance, and improvement to the landscape including gardens and trees. In 1932, their Japanese garden was dedicated by the City of Los Angeles. In 1935, the Japanese community baseball team won a championship at Stoner Playground. In the 1950s, the gardens were landscaped again under the guidance of Koichi Kawana, noted architect. In 1994, cherry blossom (sakura) trees were planted. In this way, Stoner Park plays a unique and healthy role in Sawtelle's Japantown. (Courtesy George Oshimo.)

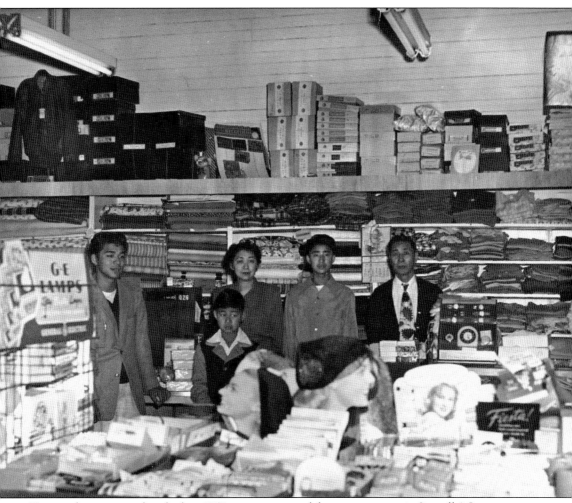

Yamaguchi was started in the late 1950s as a variety and department store in Sawtelle's Japantown at 2057 Sawtelle Boulevard. Identified in this photograph from left to right are Henry, James, Midori (mother), Jack, and Toshikazu Yamaguchi (father). Toshikazu was incarcerated in New Mexico during World War II while the rest of the family was sent to Rohwer (Arkansas), one of 10 camps set up by the War Relocation Authority for incarceration of Issei and Nikkei. Since opening the store, the brothers helped the family continue operation of Yamaguchi. It has become a Japantown landmark. (Courtesy Sid Yamazaki.)

Yamaguchi was frequented by the Japanese American community, especially students at the Sawtelle Japanese language school. They carried materials such as calligraphy brushes, writing paper, including Japanese rice paper and origami paper, and best of all, the many types of sweets relished by students. (Courtesy George Oshimo.)

Tensho Do was operated by John Toshiyuki and was across the street from Yamaguchi. He provided full service, including photograph processing. His drugstore was adjacent to the medical offices of Dr. James Goto. (Courtesy Grace Fujimoto.)

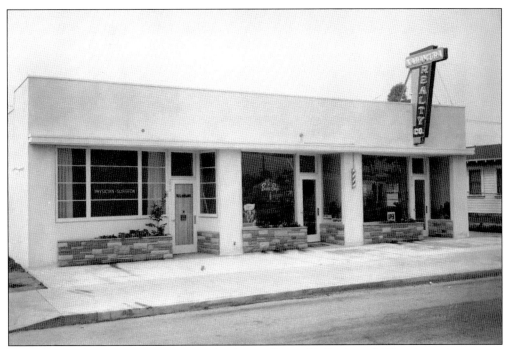

Naramura Realty was a prime property developer of Sawtelle Boulevard. The pictured structures were open for business in 1955. Occupants have added much to the flavor of Japantown. (Courtesy Victor Naramura.)

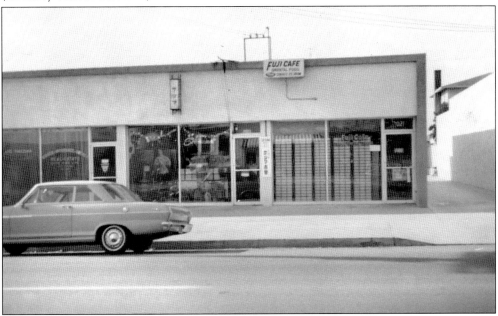

One of the early eateries along Sawtelle Boulevard was Fuji Café, which provided traditional Japanese meals. Prior to Fuji Café, the place was an ice cream and sandwich shop. This added variety to Sawtelle Boulevard eateries. North of Fuji Café on Sawtelle Boulevard was another fine eatery, Ketchie's, a small six-stool taco and burger stand, which was the eating place for many in Japantown. (Courtesy Don Sakai.)

Kaba TV was one of the early-1950s mainstays in Japantown. Tad Kaba's shop was located across the street from this unidentified man and his automobile. The shop has been displaced by Sawtelle Kitchen, a gourmet (*gurume*) restaurant. (Courtesy Don Sakai.)

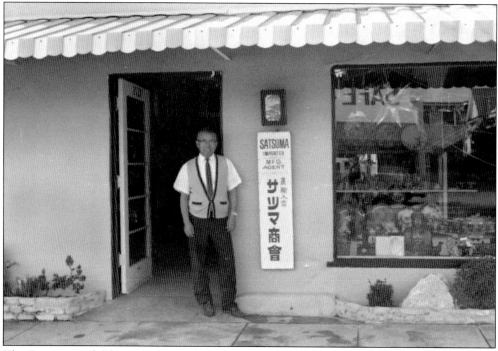

The Satsuma Gift Shop occupies a prominent space in Japantown. Don and Cynthia Sakai inherited the shop from his parents and have expanded it to sell additional and new merchandise. Pictured is Thomas Tomio Sakai (Don's father). (Courtesy Don Sakai.)

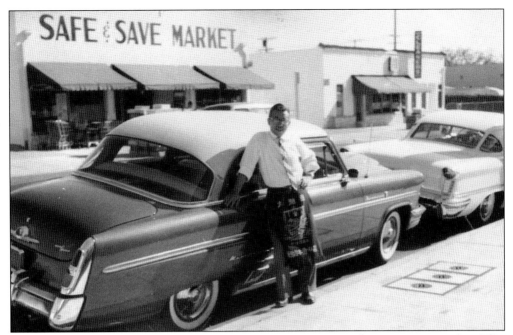

Safe and Save Market and DuBest Cleaners have been mainstays of Japantown since the 1950s. The market was owned and operated for years by Bob Iwamoto, and with his retirement, the market continues under young management. The cleaners was closed in the 1970s and relocated near the West Los Angeles municipal buildings. (Courtesy Don Sakai.)

Pictured from left to right are Tomiko Iwamoto, Rev. Bunyu Fujimura, and Bob Iwamoto. Reverend Fujimura was resident minister of the West Los Angeles Buddhist Temple from 1956 to 1975. Bob and Tomiko Iwamoto operated the Safe and Save Market until their retirement. (Courtesy George Oshimo.)

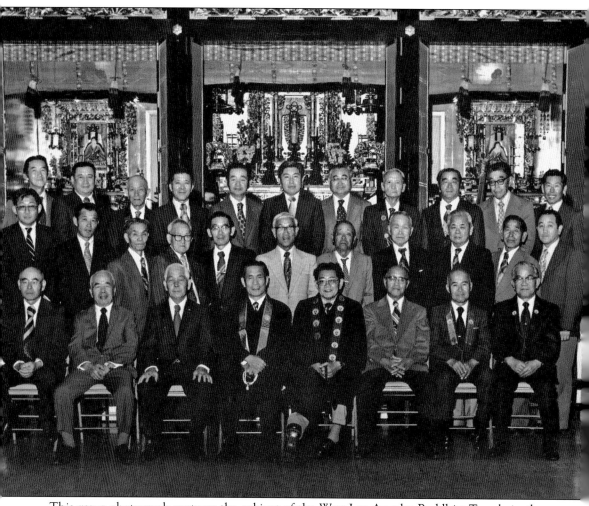

This group photograph captures the cabinet of the West Los Angeles Buddhist Temple in the early 1970s. Seated in the center are Rev. Bunyu Fujimura (left center), head minister, and Rev. Arthur Takemoto (right center). (Courtesy George Oshimo.)

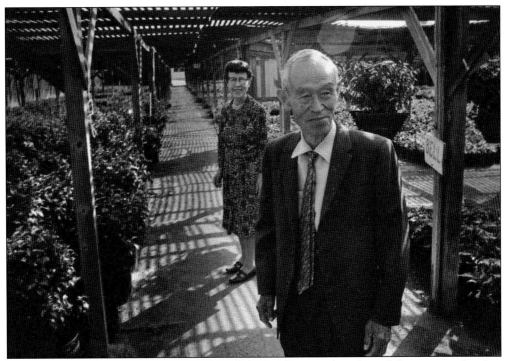

This photograph shows Masahiko and Michiko Hashimoto, founders of the nursery that has their name prominently displayed at 1947 Sawtelle Boulevard. Masahiko Hashimoto operated the OK Nursery at one time before moving to his present Sawtelle Boulevard address. He and his children have been major donors to the welfare of Sawtelle's Japantown. Annually he contributes door prizes to the Japanese Institute of Sawtelle for their New Year's party as well as to the senior recognition events. (Courtesy Sid Yamazaki.)

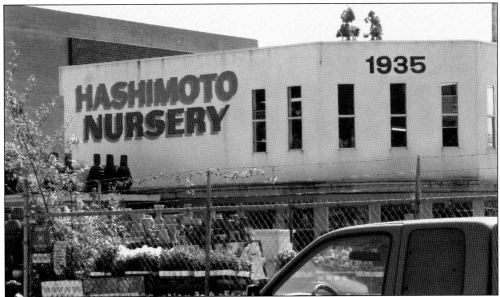

Pictured is the present-day Hashimoto Nursery on Sawtelle Boulevard. (Courtesy Jack Fujimoto.)

Pictured from left to right are Toyoko Kanegai, George Kanegai, and unidentified. The Kanegai family has been prominent in Japantown since the 1930s. George Kanegai served admirably in World War II with the U.S. Military Intelligence. A sister, Nancy Takeda, also has contributed much to the welfare of Japantown. George's wife, Toyoko, comes from the Kataoka family, which has contributed much in their own right. Her sister, Katsuko Nitta, was one of the early Japanese language teachers at Sawtelle Gakuin. All have been active in the West Los Angeles chapter of the Japanese American Citizens League (JACL) and helped many travelers through their West Los Angeles travel agency. (Courtesy George Oshimo.)

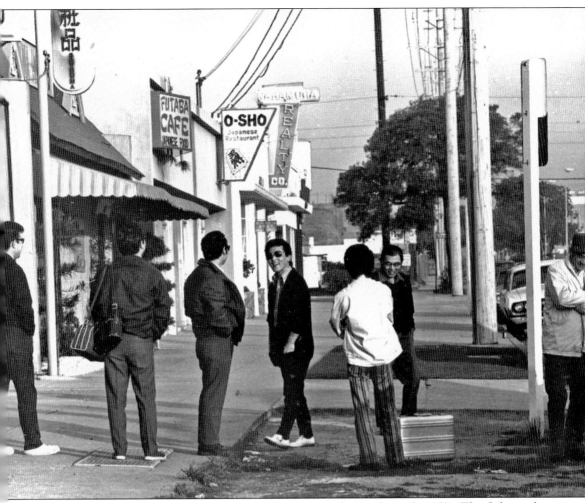

This is a Sawtelle Boulevard street scene in Japantown during the early 1950s. The Osho and Futaba restaurants brought various Japanese dishes to make Sawtelle's Japantown's reputation as Little Osaka. Osho eventually left Sawtelle and expanded to several sites in Los Angeles and the South Bay. (Courtesy Joe Nagano.)

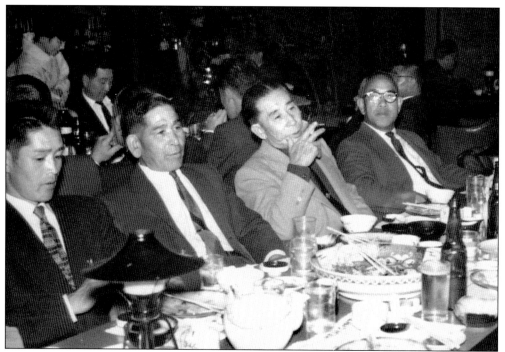

The traditional Japanese calendar calls for a BonenKai (translated as a "forget the year party"). Enjoying their party at the Kawafuku Restaurant were, from left to right, David Ikkanda, Bunsuke Shinto, ? Kato, and Tozo Yahata. (Courtesy George Oshimo.)

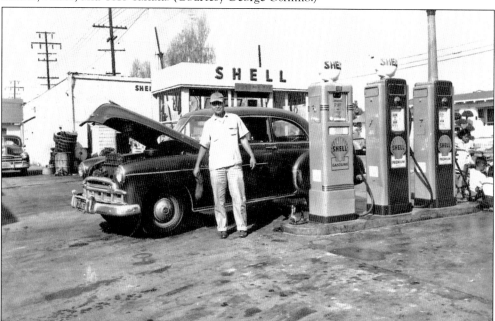

Bob's Shell Service was at the center of Sawtelle's Japantown. Bob Fujimoto was the proprietor and operator. It was one of several service stations in the area. T&T Service was north on Sawtelle Boulevard, and the Union 76 Service was to the south on Sawtelle Boulevard. (Courtesy Scott Fujimoto.)

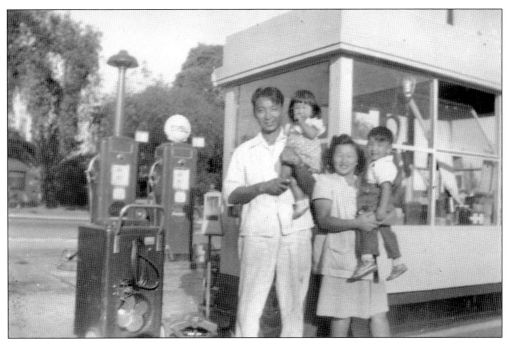

Bob Fujimoto of Bob's Shell Service is shown carrying daughter Carol and his wife, Helen, is carrying their son, Ron. (Courtesy Scott Fujimoto.)

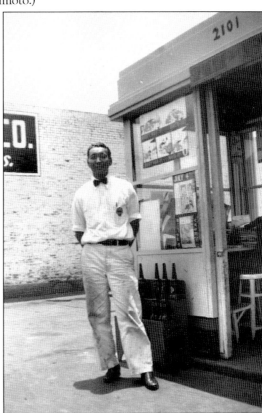

This photograph shows a young Bob Fujimoto standing before his Shell service station. (Courtesy Scott Fujimoto.)

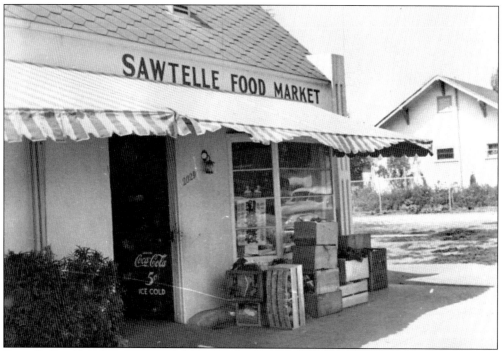

Sawtelle Food Market was one of the early postwar stores in Japantown. Fusajiro and Aki Toya featured seafood along with freshly made tofu and rice cakes (*manju*). (Courtesy Yuki Sakurai.)

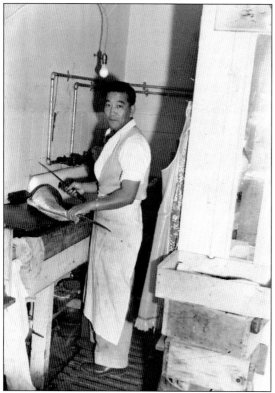

Akira Toya was a master craftsman in filleting fish at the Sawtelle Food Market. His skill made the market a stopping point for many in Japantown to have sashimi for their meals. (Courtesy Yuki Sakurai.)

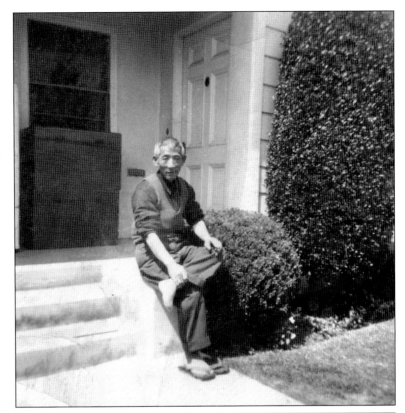

Fusajiro Toya was the owner of the Sawtelle Food Market. He is pictured sitting on the front deck of his home on Mississippi Street in West Los Angeles. (Courtesy Grace Fujimoto.)

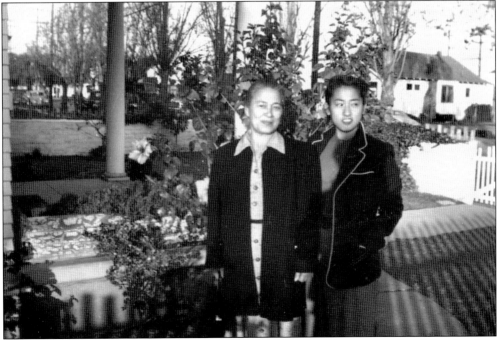

Aki Toya was co-owner and a helper at Sawtelle Food Market. She is pictured with her daughter Grace. (Courtesy Grace Fujimoto.)

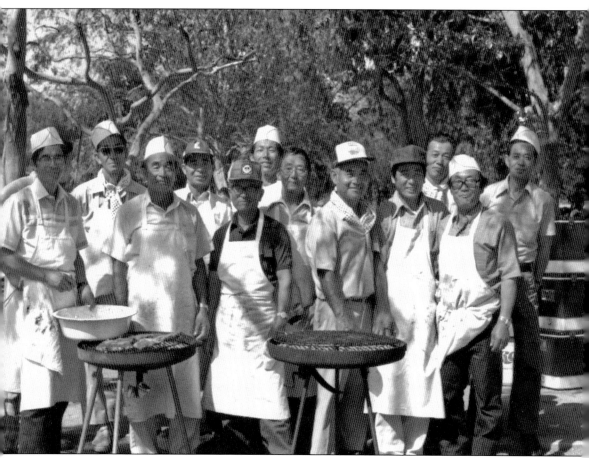
Community picnics had many volunteer cooks hovering around the many barbeque sets. This event was a great draw for adults and children alike, drawing more than 200 persons annually. Even though many of the events were similar to those held at the Japanese school field days, the Japantown community enjoyed food and games. (Courtesy George Oshimo.)

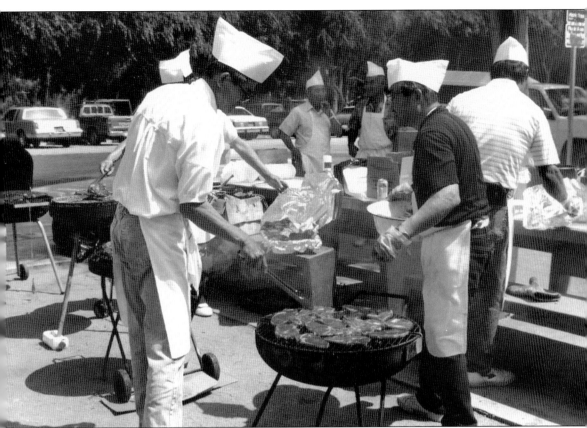

The community picnic held at Rancho Park featured many members of the Bay Cities Gardeners' Association (BCGA) testing their charred steaks. During the summer, the association invited their families to Rancho Park in West Los Angeles to enjoy food and games. (Courtesy George Oshimo.)

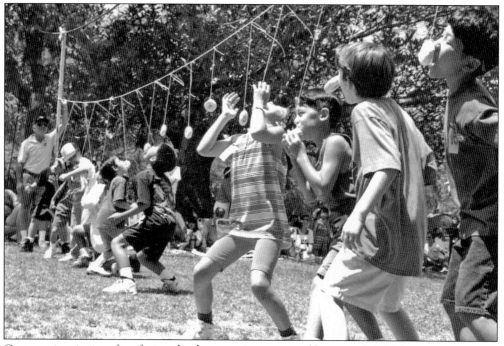
Community picnics often featured a donut-eating contest. (Courtesy BCGA.)

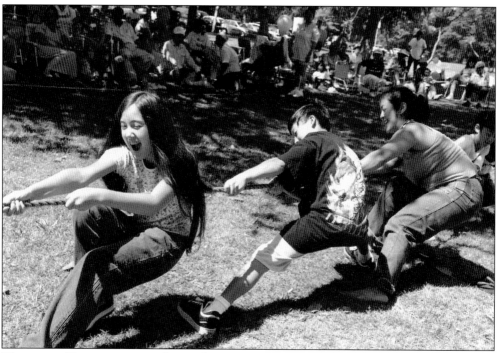
The rope-pulling contest was a featured event at community picnics. (Courtesy BCGA.)

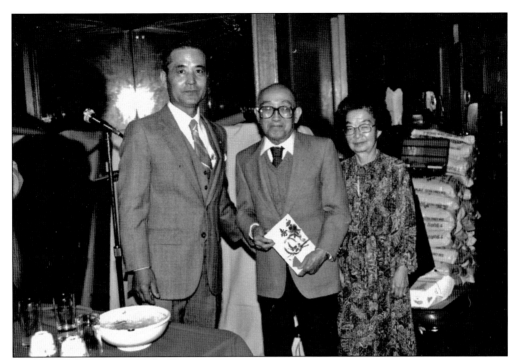

Fumio Nishina is on the left of Kentaro Morioka and his wife, Yuriko. All were active with the formation of the Bay Cities Gardeners' Association in 1958 and have been longtime contributors to Sawtelle's Japantown. Japantown lost Kentaro in 1989 when he was the victim of a hit-and-run in Japantown. (Courtesy George Oshimo.)

David Akashi was a leader of the West Los Angeles Buddhist Temple. He and his wife, Mary, mortgaged their house and assets for the newly built temple structures. David and his partner in Aka-Tani Landscape, Nob Ishitani, left their imprint on California's interstate highway landscapes. Several major interstates such as I-5 and I-15 and the famous Highway 101 have sections of landscaping designed primarily by David Akashi. (Courtesy George Oshimo.)

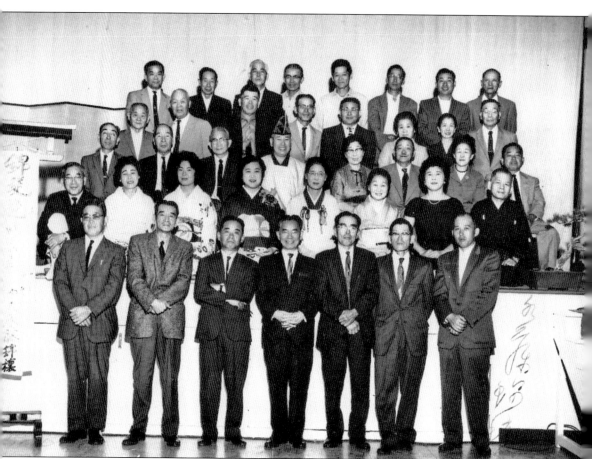

This group photograph shows members of the Suzugin Shigin group in 1962. *Shigin* is classical Japanese singing adapted to Japanese poetry. Often Japanese history is the base for their poetry or story. (Courtesy Yoshinori Kubota.)

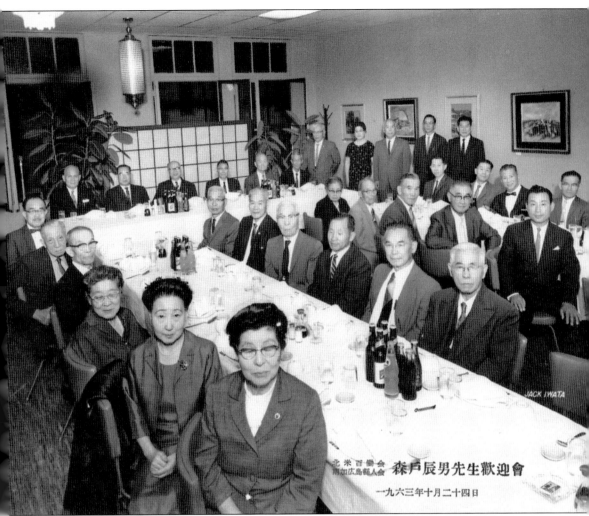

A welcoming party on October 24, 1963, for Tatsuo Morito, a new teacher at Sawtelle Gakuin, in shown in this scene. Sponsors for this party were the North American Hyakudo Kai and Southern California Hiroshima Kenjin Kai, both organizations that continue to show strong ties to traditional Japanese roots. (Courtesy Yoshinori Kubota.)

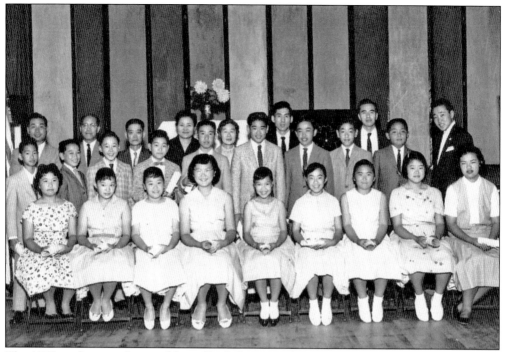
The 1959 graduating classes of Sawtelle Gakuin are showcased. This is the 15th graduation ceremony for the Japanese language school. Education was interrupted during World War II. (Courtesy Yoshinori Kubota.)

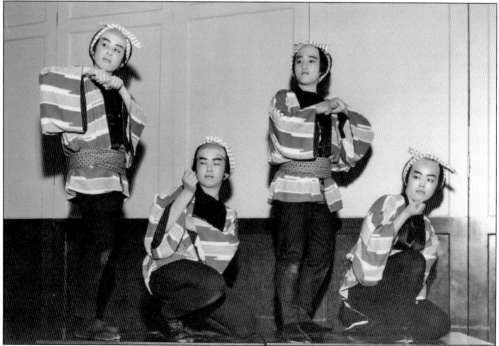
This early-1950s photograph shows students performing at Sawtelle Gakuin. From left to right are Michi Suzukawa, June Yahata, Grace Toya, and Takayo Ishii. (Courtesy Grace Fujimoto.)

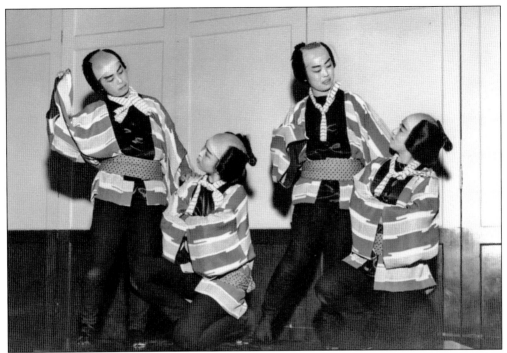

Students performed traditional, classical Japanese dances at Sawtelle Gakuin in the early 1950s. Shown from left to right are June Yahata, Michi Suzukawa, Takayo Ishii, and Grace Toya. (Courtesy Grace Fujimoto.)

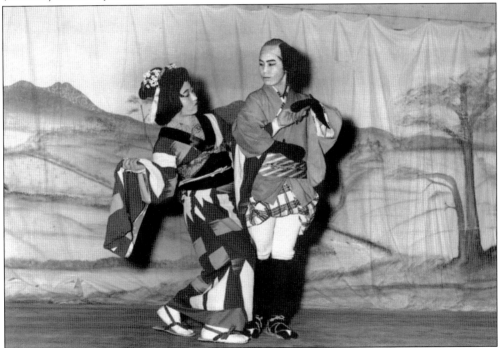

Ruth Nakagawa (right) and Grace Toya (left) perform classical Japanese dance at Sawtelle Gakuin. (Courtesy Grace Fujimoto.)

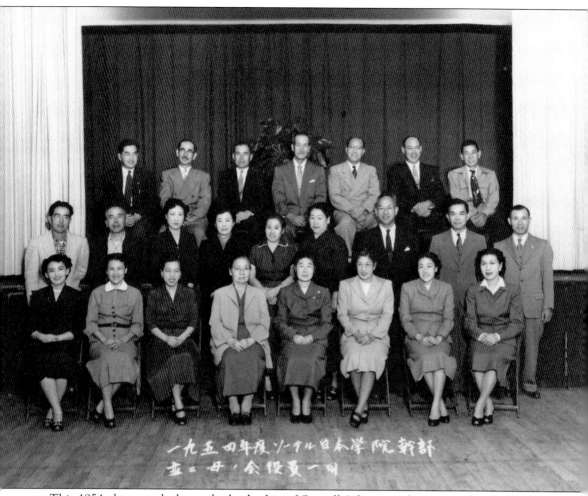

This 1954 photograph shows the leadership of Sawtelle's Japanese language school. Officers represent the board of directors as well as officers of the Mother's Club (Haha No Kai). Seated fourth from the right is school principal Fuki Hoshiyama. (Courtesy Yoshinori Kubota.)

Shig Ishii operated one of the several nurseries on Sawtelle Boulevard during the 1950s. Shig relates that there were more than 20 nurseries at one time in Sawtelle. In 1970, some Century City occupants petitioned the Los Angeles City Planning Commission to divert more traffic to the Westside, primarily using Sawtelle Boulevard. This would require a widening of Sawtelle Boulevard and disrupt the tranquil and, at times, the festive environment of Japantown. Shig Ishii organized 58 merchants to become the Sawtelle Boulevard Merchants Committee who made appearances at meetings of the Los Angeles City Planning Commission. On several occasions, Sumitomo Bank, now California Bank and Trust, chartered buses to take the merchants to those meetings. This unified community approach by Japantown interests had its impact, and Sawtelle Boulevard was left intact. This was the only occasion that Shig Ishii recalls that the Japantown interests came together to petition their government to honor a position. (Courtesy Kimi Ishii.)

The pre–World War II West Los Angeles Buddhist Temple was demolished for a newly structured building in 1950 at the same site. The temple is located at the corner of Corinth and LaGrange Avenues, just west of Sawtelle Boulevard. (Courtesy George Oshimo.)

Three

Tom Ikkanda, Community Leader

Through the distinct yet representative life of Tom Shoso Ikkanda, the vitality of Sawtelle's Japantown community (*nihonjin machi*) can perhaps be best seen. Nearing 90 years of age as this book goes to print, Tom has reflected the changing aspects of Japantown as a member of the community, religious leader, scoutmaster, businessman, and philanthropist.

Tom was born in Sawtelle on August 22, 1917. His father, Kenso, was treasurer for the Japanese Institute of Sawtelle and founder of the Sawtelle Buddhist branch of Nishi Hongwanji Betsuin in Los Angeles. Kenso owned the Oriental Nursery in Sawtelle. His interests included aviation.

Kenso wanted his children to learn the Japanese language at JIS. Tom was in the first class at Sawtelle Gakuin in 1925. Tom attended Frank Wiggins Trade School (now Los Angeles Trade-Technical College) after graduating from Warren Harding High School (now University High School). Tom was interested in guns, mechanics, and engines, becoming involved in hunting and fishing as well as racing cars, boats, and motorcycles. Tom started an automotive repair service on Pontius Avenue in 1938, then moved to Corinth Avenue at Olympic Boulevard. He and his brother John Ikkanda paid $3,500 for the southwest corner lot.

On May 18, 1941, Tom married Dorothy Yamagishi, a longtime resident of Santa Monica and graduate of Santa Monica High School. Dorothy was a student at Futaba Gakuen in Ocean Park.

In 1942, Executive Order 9066 from President Roosevelt resulted in Tom and Dorothy joining the mass exodus to Manzanar Concentration Camp, near Mount Whitney in the Sierra Nevada. After seven months, they were permitted to relocate to Reno, Nevada, to join relatives. Tom began repairing engines at the Navy Pilot Training Facility near Susanville, California, and became indispensable, as test pilots were unavailable. Then without pilot training, he took his refurbished planes for test runs, often over restricted zones such as San Francisco Bay.

While in Reno, Dorothy gave birth to Richard and Marty. After they returned to Sawtelle in 1948, their daughter Donna was born. Tom operated garages in three locations in Sawtelle and later a Japanese car engine import business, often going to Japan for negotiations. Tom was active in Troop 39 of the Boy Scouts of America for most of his life and indulged in his passions of guns, racing cars, racing boats, and aviation. Tom also was president of the West Los Angeles Buddhist Temple for three years.

Through an inclusive view of his life through images, the changes in Sawtelle's Japantown become obvious.

Tom Shoso Ikkanda is pictured as an elder member of the West Los Angeles Buddhist Temple. He has been temple president as well as president of its male group, the Buddhist Men. He and his wife, Dorothy, are devout temple visitors. (Courtesy George Oshimo.)

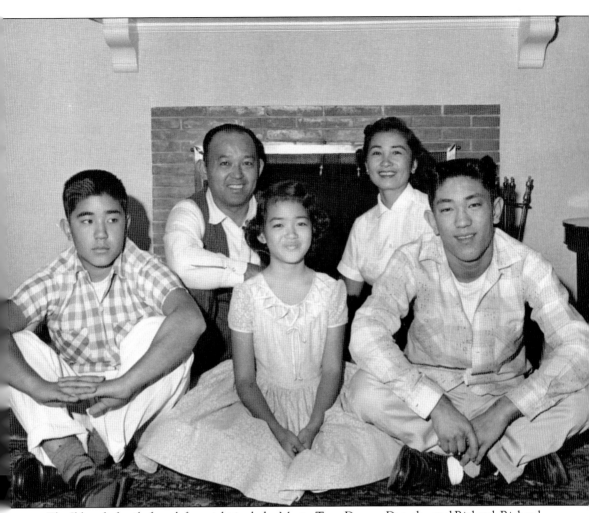

The Ikkanda family from left to right includes Marty, Tom, Donna, Dorothy, and Richard. Richard and Marty were born in Reno, Nevada, during World War II, with Donna born later in Sawtelle. (Courtesy Tom Ikkanda.)

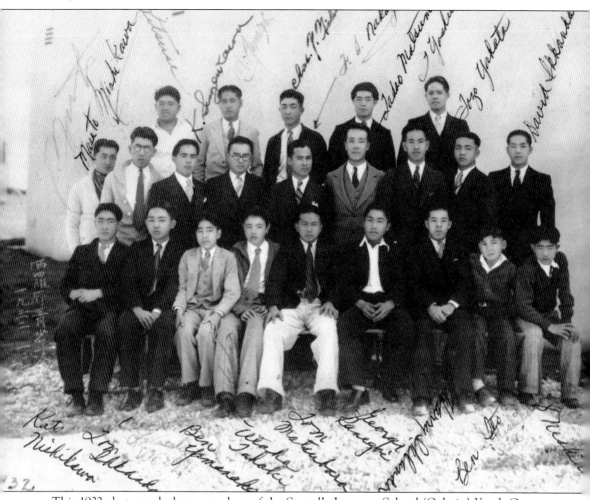

This 1932 photograph shows members of the Sawtelle Japanese School (Gakuin) Youth Group. Tom is seated in the first row, second from the left. (Courtesy Tom Ikkanda.)

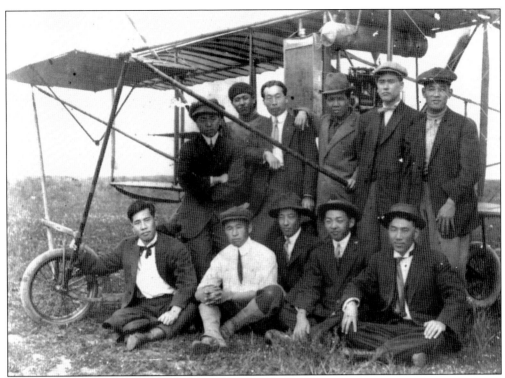

The 1914 flight training class in the South Bay included several Japanese immigrants. Among them was Tom's father, Kenso Ikkanda. Kenso is seated second from the right. (Courtesy Tom Ikkanda.)

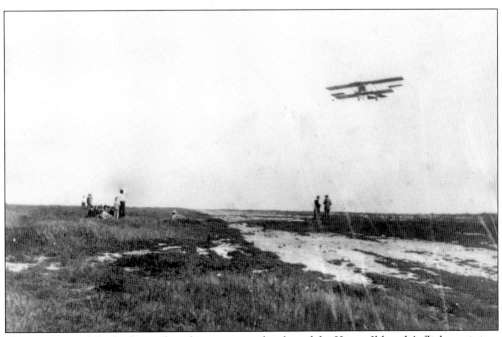

Shown is one of the biplanes that the aviation school used for Kenso Ikkanda's flight training. Tom Ikkanda developed an interest in all facets of aviation in his life. (Courtesy Tom Ikkanda.)

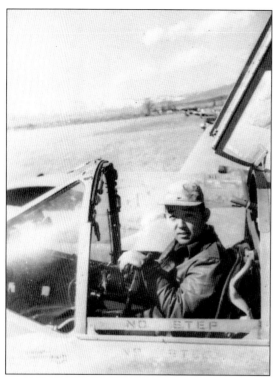

This 1945 photograph shows Tom Ikkanda sitting in the cockpit. It was one of the planes that he worked on at the military service base in Northern California. With the shortage of pilots during that World War II period, he learned to fly and often flew in restricted corridors that were off-limits to Japanese Americans. (Courtesy Tom Ikkanda.)

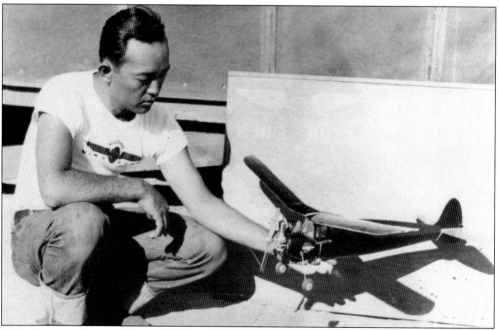

This photograph was taken in 1942 and shows Tom Ikkanda with a model airplane while in Block 16 of Manzanar Concentration Camp in the shadows of Mount Whitney. He ordered the model kit from a store on Pico Boulevard in West Los Angeles. Tom belonged to the Wing Nuts Club in his early years, which helped to solidify his interests in airplanes and flying. (Courtesy Tom Ikkanda.)

Pictured is the 1929 staff of volunteers for the Japanese Institute of Sawtelle (JIS). Kenso Ikkanda is in the first row, seated at far left. (Courtesy Joe Nagano.)

Tom Ikkanda is one of four charter members of Sawtelle Gakuin's first Japanese language class. Tom is third from the left in the third row. (Courtesy Tom Ikkanda.)

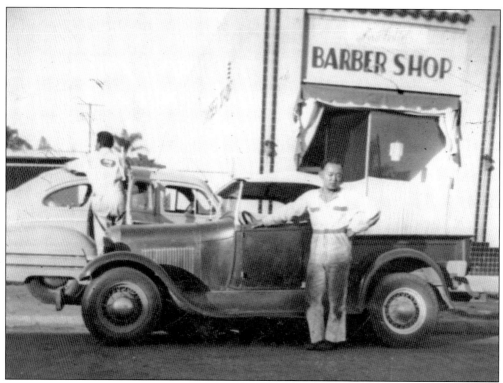

Tom Ikkanda stands in front of his Ford Model A at his first post–World War II repair shop. The shop is adjacent to Al Ito's barbershop on Sawtelle Boulevard. (Courtesy Tom Ikkanda.)

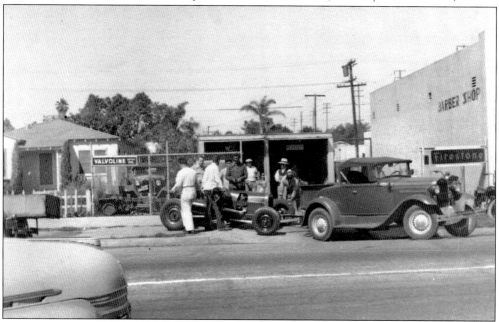

In 1947, Tom Ikkanda rented this property for his garage. His shop, Ikkanda Automotive, was adjacent to Willie Funakoshi's insurance office. He was pulling a racing car with his Ford Model A. (Courtesy Tom Ikkanda.)

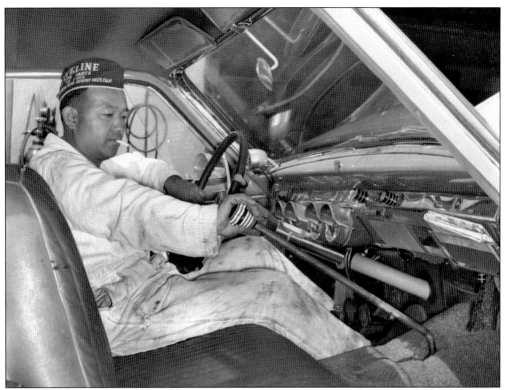

Tom Ikkanda is thinking of his work in progress while smoking a cigarette. This 1950 Studebaker automobile had a Chevrolet V-8 engine installed. (Courtesy Tom Ikkanda.)

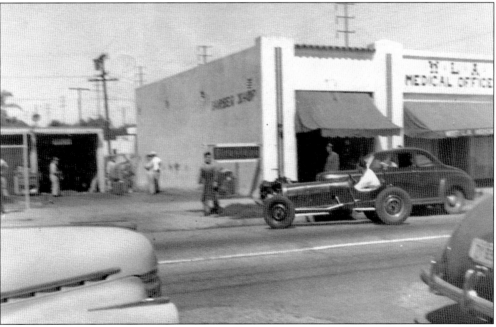

Tom Ikkanda drives his racing car on Sawtelle Boulevard in the heart of Japantown in 1948. (Courtesy Tom Ikkanda.)

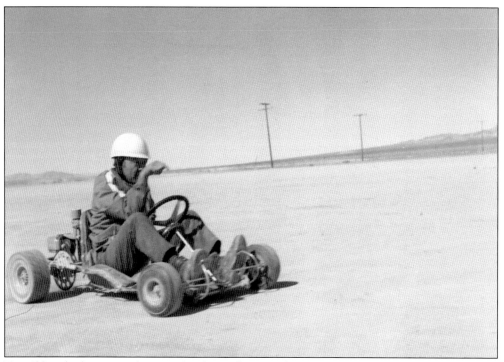
Tom Ikkanda drives a go-kart on the desert floor at El Mirage, east of Palmdale, California, in June 1969. (Courtesy Tom Ikkanda.)

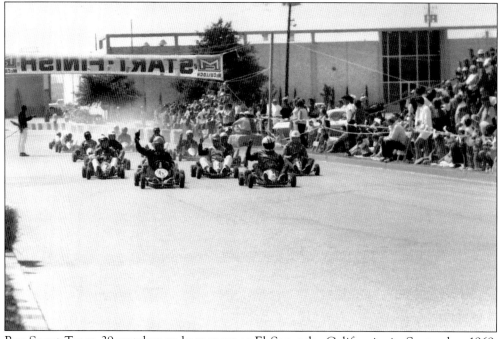
Boy Scout Troop 39 watches go-kart races at El Segundo, California, in September 1969. (Courtesy Tom Ikkanda.)

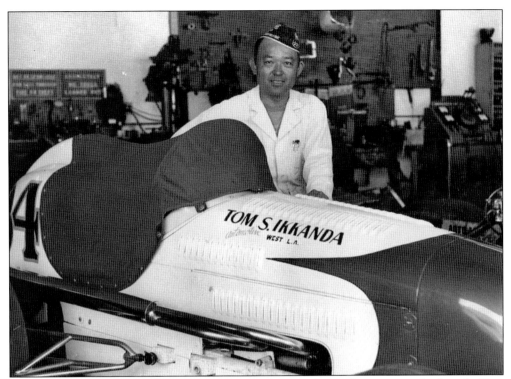

This is Tom Ikkanda's racing car, No. 34. He took care of several racing cars for friends. Tom took his racers to Gilmore, Gardena, and Saugus tracks during the early 1950s. One of his fondest repairs was to Tyrone Power's 1914 car. (Courtesy Tom Ikkanda.)

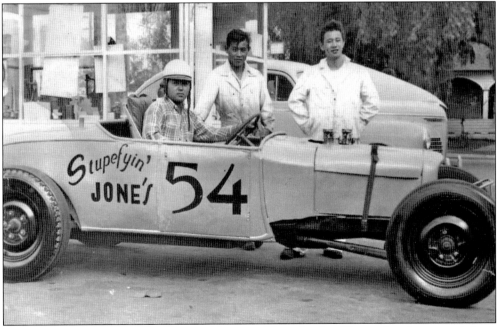

Tom Ikkanda drives his No. 54 racing car. The name "Stupefyin Jone's" was taken from a comic book that Tom was reading. Fred (center) and Frank Ige are the onlookers. (Courtesy Tom Ikkanda.)

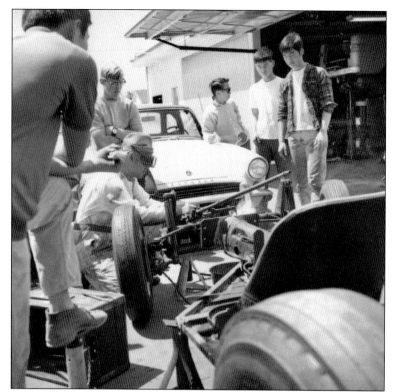

Tom Ikkanda is welding the chassis of a car. He used this method as a learning experience for Troop 39 Scouts. (Courtesy Tom Ikkanda.)

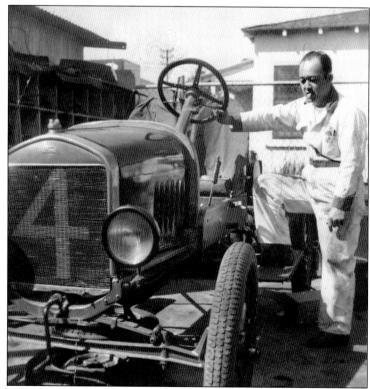

Tom Ikkanda is assessing ways to convert a Ford Model T to a racing car in this 1950 photograph. (Courtesy Tom Ikkanda.)

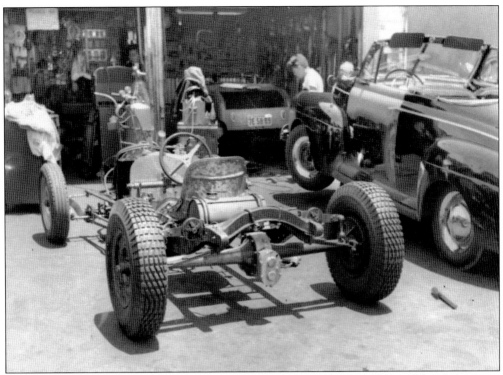

Tom Ikkanda is converting a Ford chassis for racing purposes. (Courtesy Tom Ikkanda.)

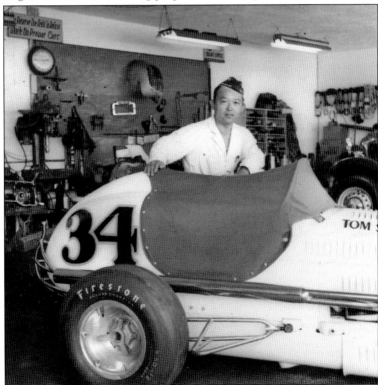

Tom Ikkanda finished preparation of his No. 34 racing car. (Courtesy Tom Ikkanda.)

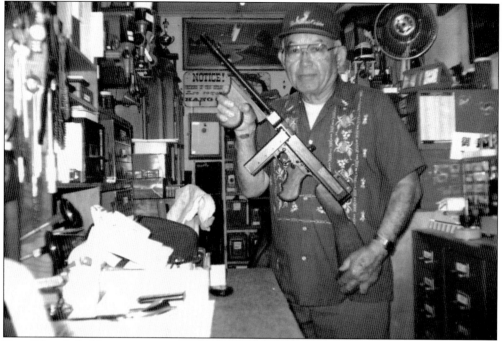

Tom Ikkanda holds an automatic weapon from his personal arsenal. He became interested in guns while going to high school (about 1936). In 1970, he joined the National Rifle Association (NRA). (Courtesy Tom Ikkanda.)

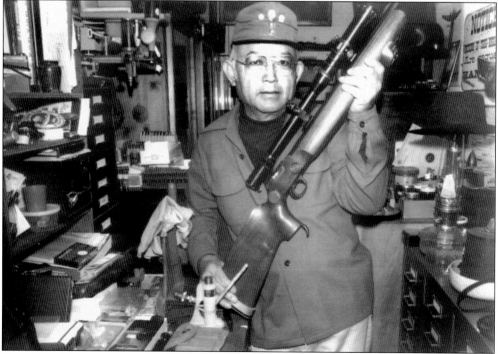

Tom Ikkanda's interest in guns carried through to his scoutmaster role when Scouts went to qualify for merit badges using similar guns to the one he holds in his hands. (Courtesy Tom Ikkanda.)

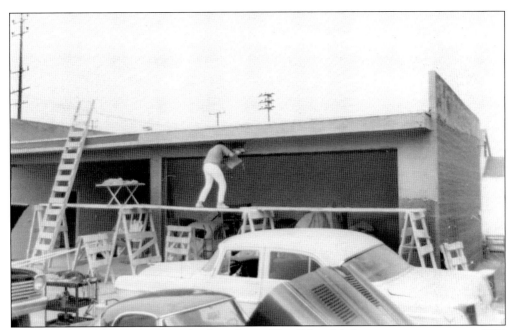

Construction workers are making final touches to Tom Ikkanda's first permanent garage at 1920 Sawtelle Boulevard. (Courtesy Tom Ikkanda.)

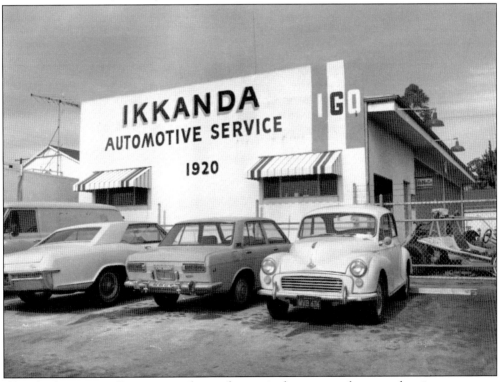

Ikkanda Automotive Service was a haven for repaired cars, motorboats, and racing cars, many of which were for sale. In front of the office was posted "Not Open to the Public," but the sign did not deter patrons. (Courtesy Tom Ikkanda.)

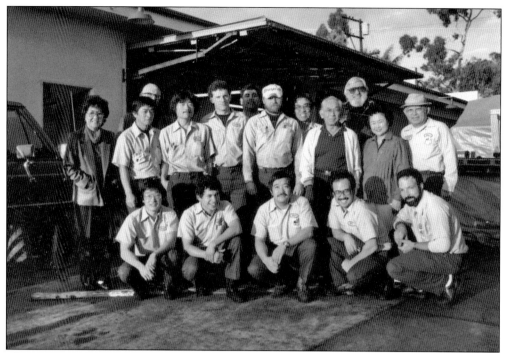
The permanent garage staff at Ikkanda Automotive Service is pictured. Most stayed with him until his garage was sold in 1988. (Courtesy Tom Ikkanda.)

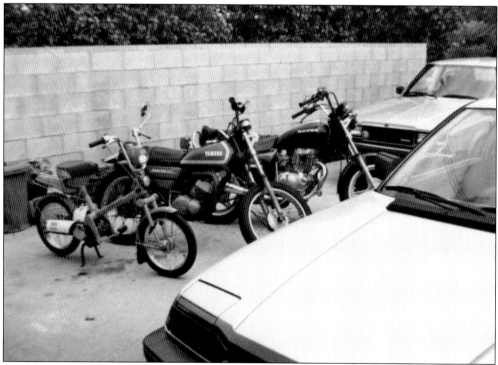
Tom Ikkanda repaired motorbikes and motorcycles for sale. On other occasions, he had his Troop 39 Scouts ride them. (Courtesy Tom Ikkanda.)

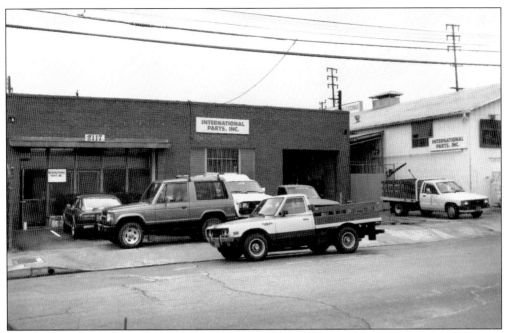

Tom Ikkanda established International Motor Parts, Inc., at 2117 Pontius Avenue, West Los Angeles, after selling his garage. His new venture was to import Japanese motorcar engines. (Courtesy Tom Ikkanda.)

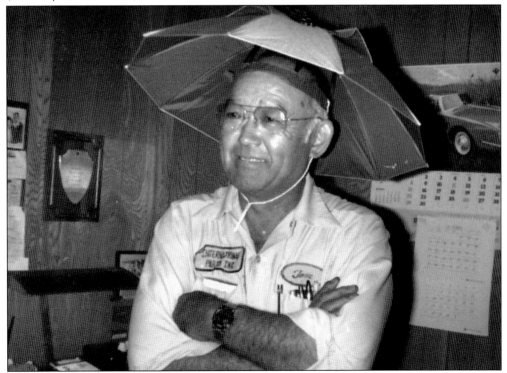

Tom Ikkanda is wearing a gift given to him by his Japanese engine vendor. This was an umbrella cap. (Courtesy Tom Ikkanda.)

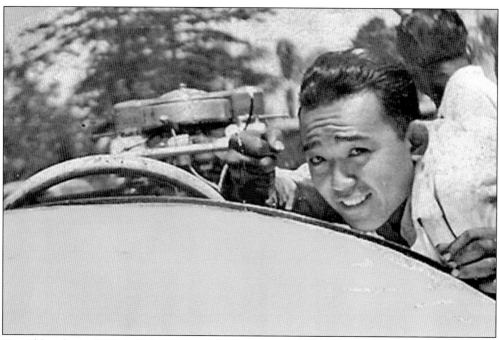

Tom Ikkanda, in 1939, is fixing a racing boat with a class B outdoor motor. It is a hydro boat. (Courtesy Tom Ikkanda.)

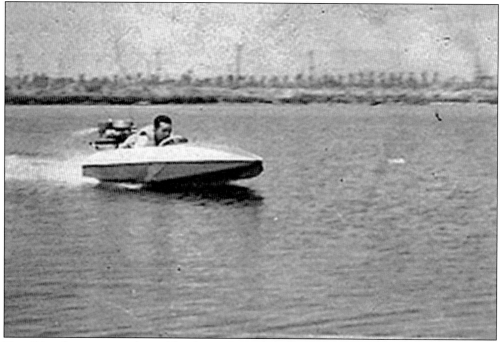

Tom Ikkanda races motorboats like this with a refurbished engine at Lake Los Angeles. While in high school, Tom participated in racing events as a member of the Warren G. Harding Racing Club. (Courtesy Tom Ikkanda.)

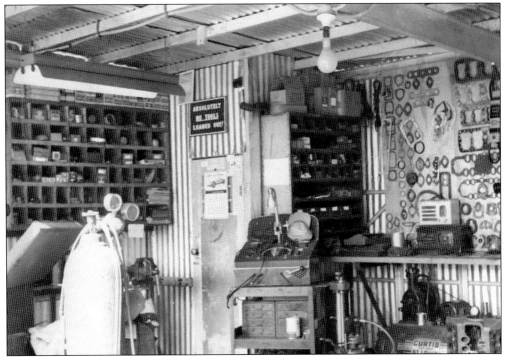

Tom Ikkanda's shop carried several signs that showed his work ethic. One sign said, "Absolutely No Tools Loaned Out!" (Courtesy Tom Ikkanda.)

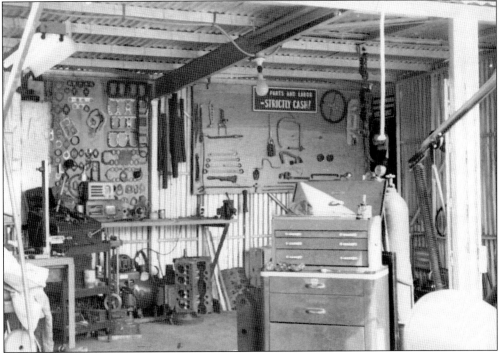

Tom Ikkanda turned to "Strictly Cash" because he was losing much on credit loans. (Courtesy Tom Ikkanda.)

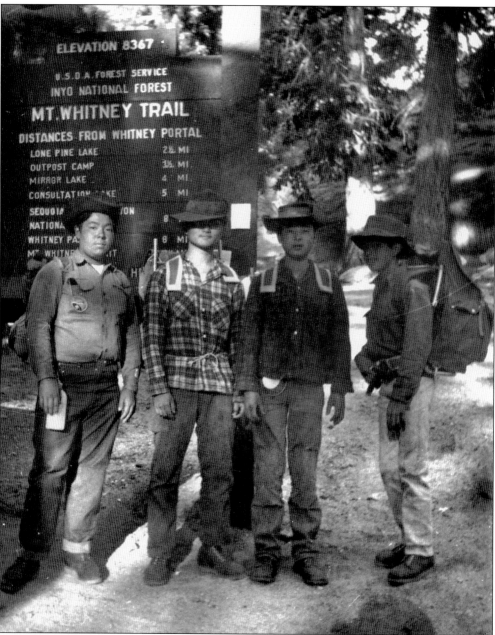
Scouts from Troop 39 pose on Mount Whitney Trail in their summer outing. Pictured from left to right are Eddie Nakamura, John Maruyama, Eddie Ikuta, and Stanley Onami. Stanley Onami eventually received recognition from the Buddhist Churches of America with a Sangha Award, the highest merit award from this national religious organization. (Courtesy Tom Ikkanda.)

Troop 39 Scouts are eating breakfast in a High Sierra outing. From left to right are Victor Naramura, John Maruyama, and Alan Nakamura. (Courtesy Tom Ikkanda.)

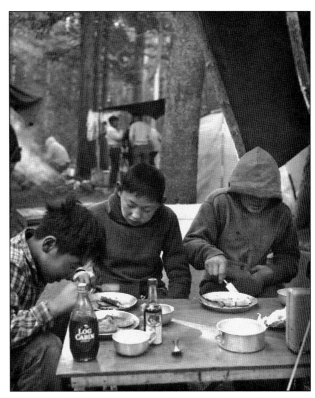

Troop 39 Scouts rest while on a hike to the Santa Monica Mountains and San Fernando Valley. (Courtesy Tom Ikkanda.)

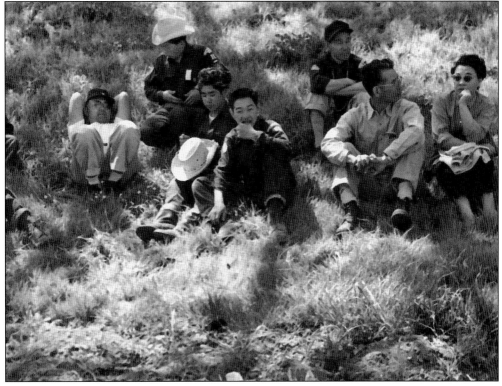

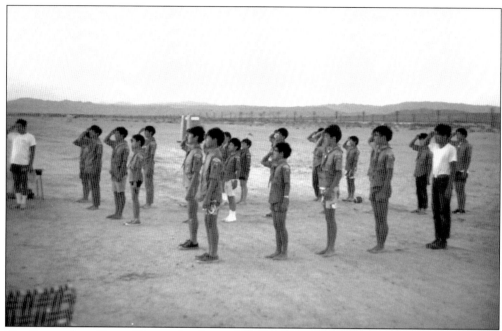
The Scouts from Troop 39 start the day at Salton Sea standing at attention. This was part of their training. This photograph was taken in December 1970. Salton Sea is California's only large saltwater lake and is in the Southern California desert where temperatures range from 30 to 120 degrees Fahrenheit. (Courtesy Tom Ikkanda.)

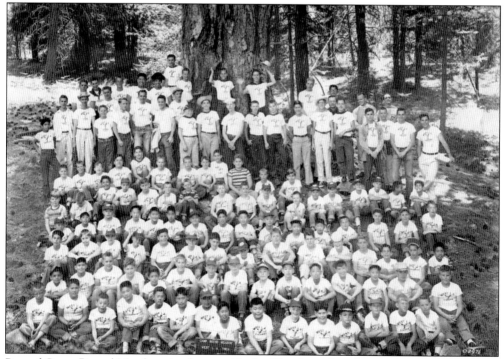
Part of Camp Round Meadows jamboree with the West Lost Angeles YMCA were the Scouts from Troop 39. This photograph was taken in 1956. (Courtesy Tom Ikkanda.)

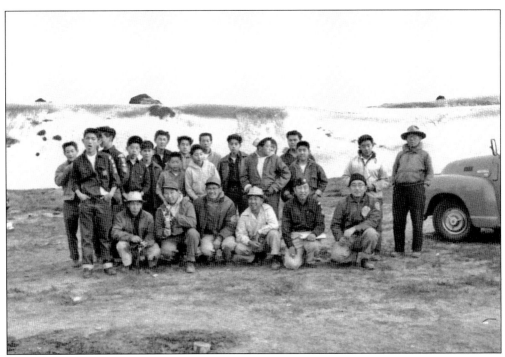
Troop 39 Scouts and supervisors are on a field trip to Baja California in the 1960s. (Courtesy Tom Ikkanda.)

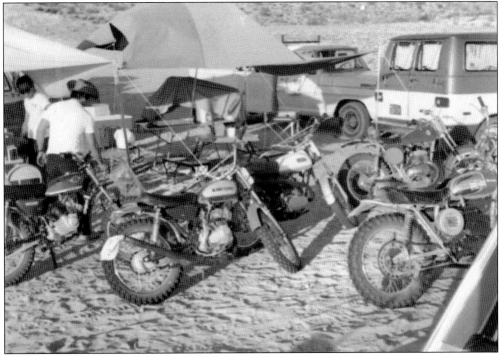
This motorbike rally was held at Red Rock Canyon in October 1971. The canyon is in the Mojave Desert. (Courtesy Tom Ikkanda.)

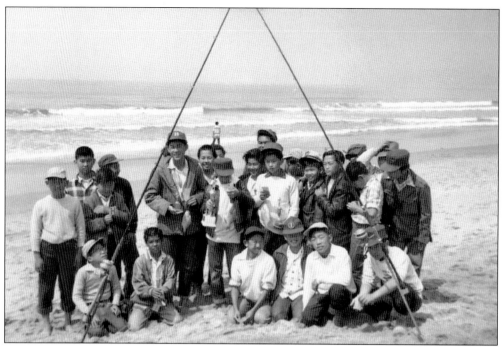
Troop 39's annual outing took them to Oceano and Pismo Beach on the Central California coast, where Scouts developed their surf-fishing skills. They cleaned their own catch, and trophies and awards were given for various categories of catches. (Courtesy Tom Ikkanda.)

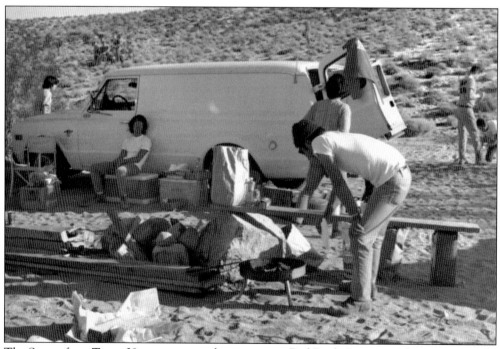
The Scouts from Troop 39 are preparing for camping at Red Rock Canyon in the Mojave Desert in February 1973. (Courtesy Tom Ikkanda.)

Troop 39 Scouts are on their way to climb Mount Whitney and Mammoth Mountains in 1969. (Courtesy Tom Ikkanda.)

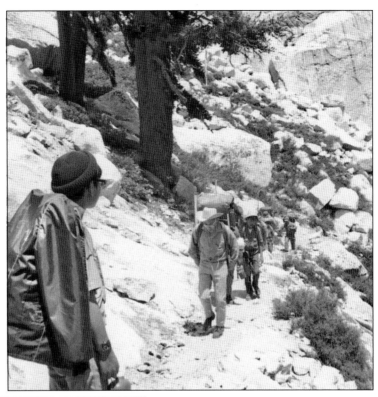

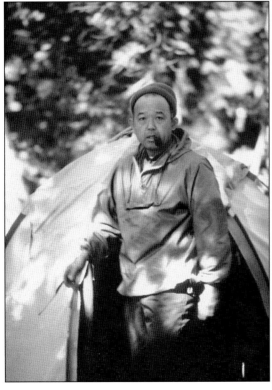

Scoutmaster Tom Ikkanda emerges from a special Scout tent perched in the Mammoth Mountain and Horseshoe Lake area of the High Sierra. (Courtesy Tom Ikkanda.)

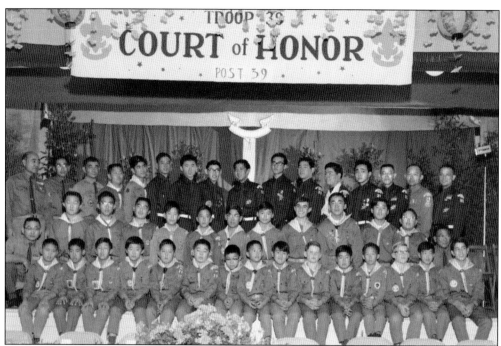

The Court of Honor for Troop 39 honored 50 Scouts in the Tenderfoot, Scout, and Explorer categories. Tom Ikkanda is second from right in the third row. Commissioner Dr. Milton Inouye, a prominent Japantown optometrist, is standing on the far left in the third row. (Courtesy Tom Ikkanda.)

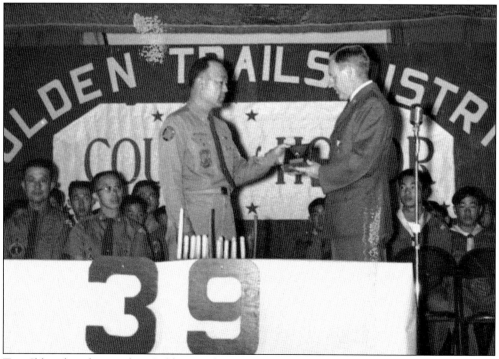

Tom Ikkanda is honored at Golden Trails District Court of Honor as Troop 39's scoutmaster. (Courtesy Tom Ikkanda.)

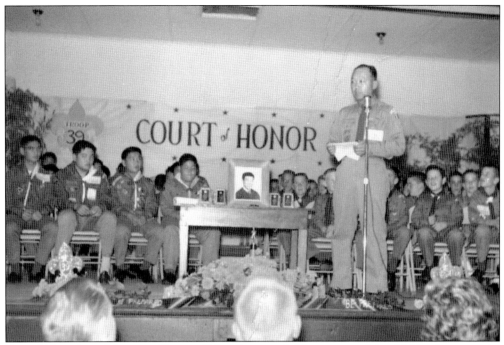

Tom Ikkanda addresses Troop 39's Court of Honor in this 1962 photograph. (Courtesy Tom Ikkanda.)

The Eagle Scout ceremony in 1960 was held at the Japanese Institute of Sawtelle. (Courtesy Tom Ikkanda.)

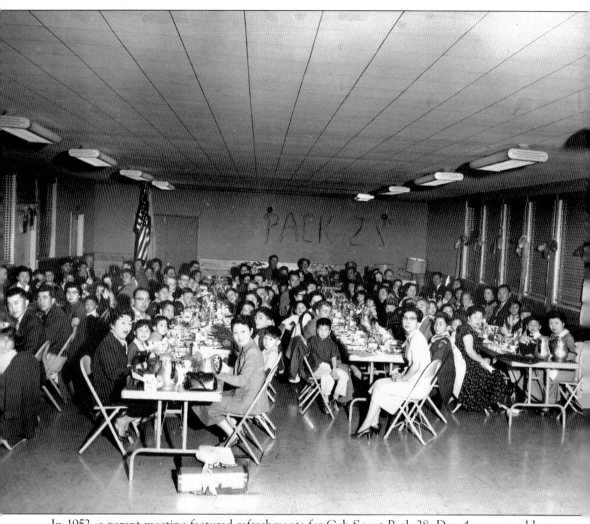

In 1952, a parent meeting featured refreshments for Cub Scout Pack 28, Den 4, sponsored by Tom Ikkanda and his staff. (Courtesy Tom Ikkanda.)

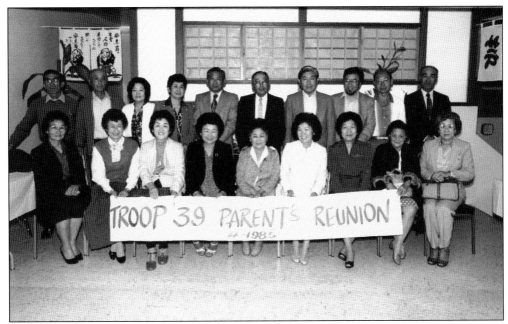

The Troop 39 Parents' Reunion in April 1985 was held at Aki Restaurant on Santa Monica Boulevard, West Los Angeles. (Courtesy Tom Ikkanda.)

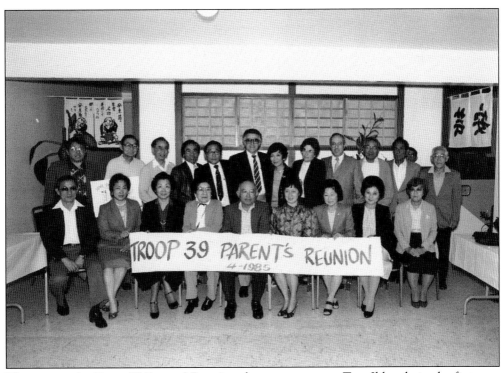

This image of a Troop 39 Parents' Reunion shows scoutmaster Tom Ikkanda in the first row, center. (Courtesy Tom Ikkanda.)

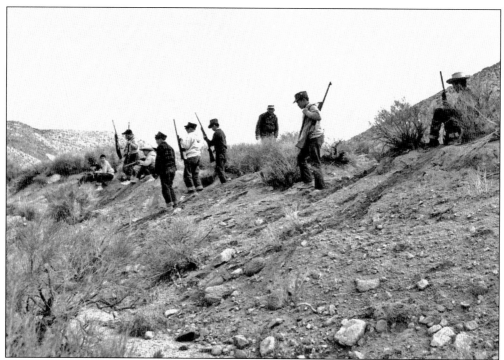
Troop 39 Scouts practice gunmanship in Lone Tree Canyon in the Mojave Desert, California. (Courtesy Tom Ikkanda.)

A New Year's Eve party was held in 1947 to celebrate Tom Ikkanda's new racing car. (Courtesy Tom Ikkanda.)

Four

Social, Institutional, and Recreational Life

Sawtelle Japantown has seen its Japanese village (*nihonjin machi*) transformed over the years through changing ethnicities and types of shops, institutions, and organizations along Sawtelle Boulevard.

The annual Nikkei events continue to be calendared and held with a younger cadre of Japanese Americans in leadership roles. Beyond periodic fund-raisers and fairs by many organizations in the Sawtelle Nikkei community, the traditional Japanese dances and music are featured at the annual New Year's parties at the Japanese Institute of Sawtelle (JIS), churches, picnics, and school activities.

The Buddhist observance of Obon during the summer reunites families as relatives return to Sawtelle, uniting members with Japanese heritage through dance, music, and food. The West Los Angeles chapter of the Japanese American Citizens League remains one the nation's largest chapters; once its more than 1,000 members made it America's largest JACL chapter. The chapter's auxiliary has the distinction of being the only all-female group among JACL chapters.

Troop 39 Scouts and graduates conduct annual courts of honor and continue periodic fund-raisers for merit awards and camping trips. Eagle Scout projects involve upgrading JIS facilities. The Sawtelle Judo Dojo, dating to the 1920s, competes nationally and internationally. The Sawtelle Kendo Dojo maintains a rigorous schedule at JIS, which is also a venue for classes or programs in the abacus, Japanese classical dance, and senior citizen nutrition. JIS houses the Japanese language Sawtelle Gakuin and devotes weekends to school activities.

Social groups such as the Jodies, San Souci, and Atomettes were formed in the 1950s to become an integral part of Japantown's activities. Musical elements in Japanese culture became a significant part of what made Japantown boom. The Nishimura Kai continues traditional folk dancing and singing (*minyo*). The Yokotake Family Band provided dance music to many Sawtelle events. Karaoke through organizations such as the LA Kayo Club promotes singing. The Bando and Fujima schools of classical Japanese dances are taught in Sawtelle. The *taiko* (drumming) has become another staple in the promotion of Japanese arts.

The annual community picnics and the orchid and bonsai shows sponsored by the Bay Cities Gardeners' Association have enriched the Sawtelle Japantown image. Also, Japanese foods promoted through eateries or events have helped label Sawtelle's Japantown Little Osaka.

Pictured is George Oshimo, longtime chronicler of Sawtelle institutions, organizations, and events. He has been the backbone of the photograph collection at the Bay Cities Gardeners' Association and organizer of the West Los Angeles Buddhist Temple Camera Club. He has put up photograph exhibits for Nisei Week in Little Tokyo and for the Los Angeles–Nagoya sister cities connection. (Courtesy George Oshimo.)

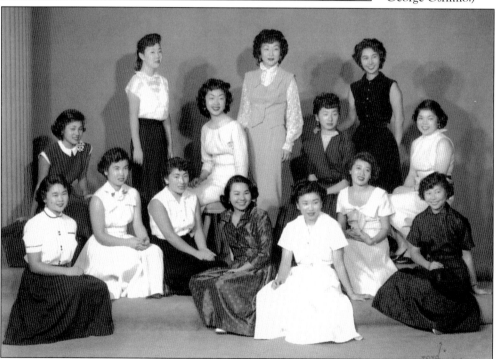

Pictured are the Capris, a social organization formed in the late 1940s through their association at University High School, a school attended by most of the Sawtelle's Japantown youth. (Courtesy Grace Fujimoto.)

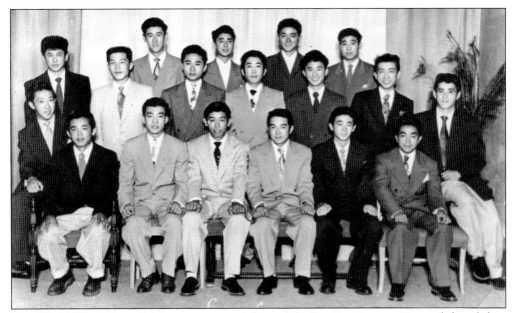

Post–World War II Sawtelle's Japantown youth formed the San Souci group. Pictured, from left to right, are (first row) Joe Ige, Charlie Inatomi, Yosh Nishimoto, Hiro Kageyama, George Kiriyama, and Joe Iwanaga; (second row) Hammer Middo, Herb Isono, Richard Kame, George Toya, Yukio Uemura, Tak Okabayashi, Bob Kame, and Akio Hori; (third row) Francis Kishi, Jackie Yamaguchi, Richard Kitabayashi, and Roy Ito. (Courtesy George Toya.)

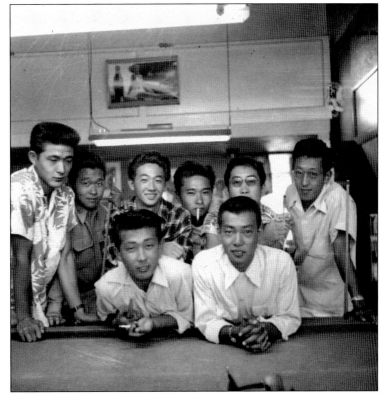

Members of the San Souci youth group enjoy playing pool in Japantown. Pictured in the second row are George Kiriyama (third from left) and George Toya (fourth from left), who are original founders of the Japanese American Historical Society of Southern California. (Courtesy George Toya.)

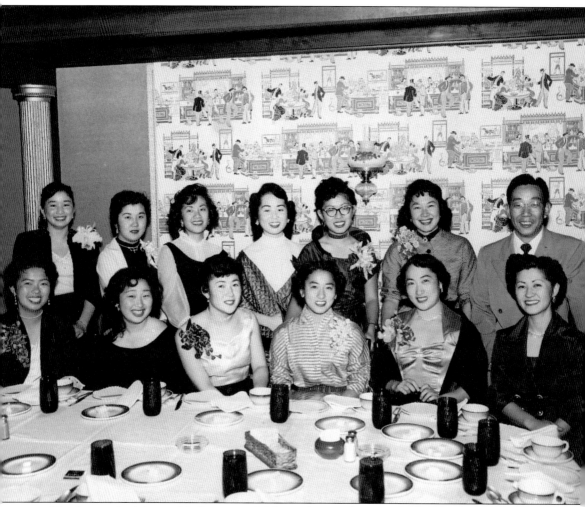

Members and advisors of Jodies, a youthful social group born in the late 1940s and active in the 1950s, are shown. They provided much community service through shows, dances, and entertainment. From left to right are (first row) June Yahata, Lorraine Fukuda, June Arima, Grace Toya, Yuki Sakurai (advisor), and Miki Uyeda (advisor); (second row) Tamiko Kitahara, Jean Onomichi, June Iwamoto, Michi Suzukawa, Takayo Ishii, Aya Tamiya, and Joe Uyeda (advisor). (Courtesy Grace Fujimoto.)

Pictured is a group photograph of Jodies. (Courtesy Grace Fujimoto.)

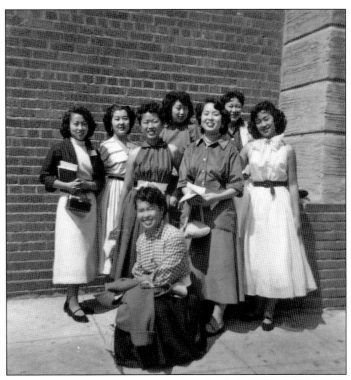

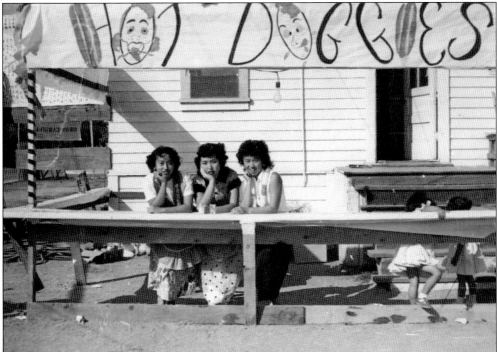

This photograph shows the hot dog booth at the West Los Angeles Buddhist Temple Obon festival in late 1940s. Pictured from left to right are Grace Toya, Michi Suzukawa, and Hiroko Kawabata. (Courtesy Grace Fujimoto.)

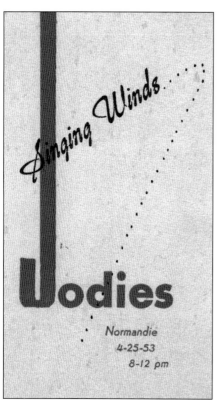

Shown is one of many tickets of events such as community dances sponsored by Jodies, a social group in Sawtelle's Japantown. (Courtesy Grace Fujimoto.)

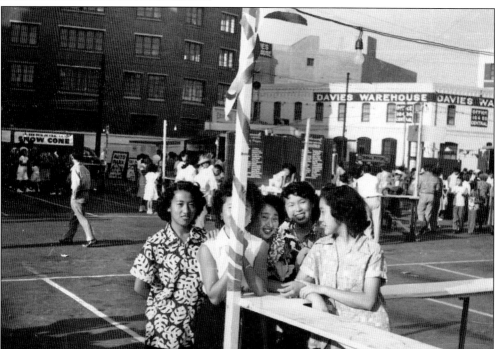

Members of Jodies participated at the Los Angeles Hompa Hongwanji Betsuin Obon in this photograph. Jodies were prominent in Obon activities. (Courtesy Grace Fujimoto.)

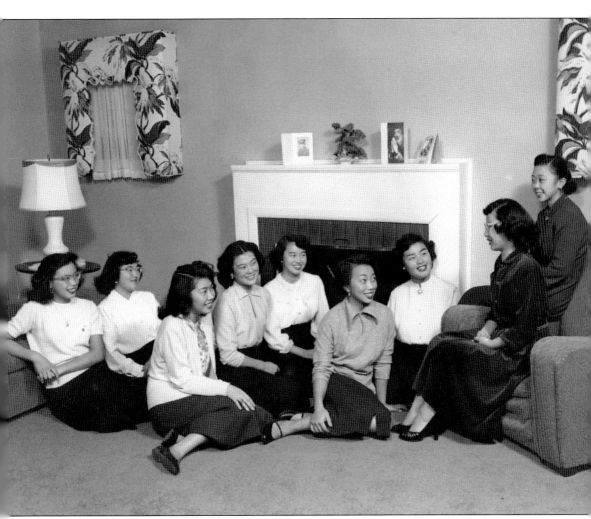

Members of the Atomettes, a girls' club of the 1950s in Sawtelle's Japantown and primarily affiliated with the West Los Angeles United Methodist Church, are seated with their advisors. From left to right, they are Susan Hashizume, Kathy Miyake, Michi Yamaji, Taye Noda, Frances Watanabe, Sadie Inatomi, Karlene Nakanishi, Rose Honda (advisor), and Mary Ishizuka (advisor). (Courtesy Sid Yamazaki.)

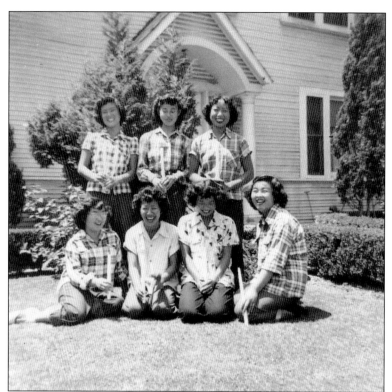

The Atomettes are pictured in 1950 at the main entrance to the old United Methodist Church at 1913 Purdue Avenue, West Los Angeles. (Courtesy Sid Yamazaki.)

This 1952 photograph shows Hobie Fujiu (right) and Sadie Inatomi at the United Methodist Church bazaar. (Courtesy Sid Yamazaki.)

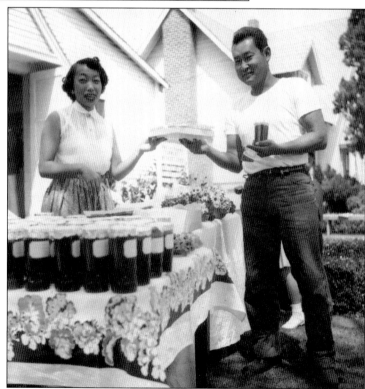

Taye Noda (left) and Sadie Inatomi host a bake sale in 1950s at the United Methodist Church. (Courtesy Sid Yamazaki.)

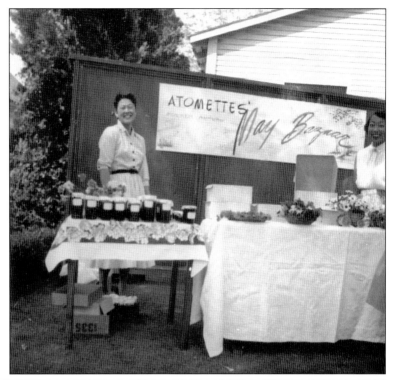

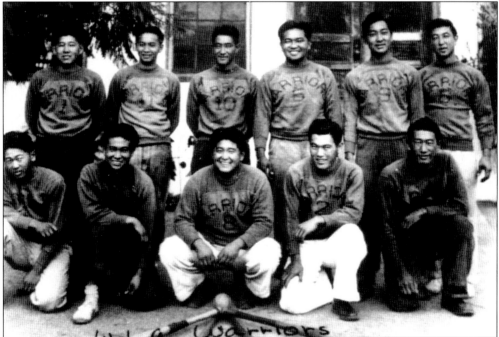

The West Los Angeles Warriors were a Japantown baseball team in the 1950s. Pictured from left to right are (first row) Willie Fujioka, Tets Ando, James Kitsuse, Hideo Kakehashi, and George Nakao; (second row) Paul Kitsuse, Koshi Ando, Katsumi Nishikawa, Ben Yoshiwara, Masaharu "Mush" Tokunaga, and George Sakamoto. (Courtesy Joe Nagano.)

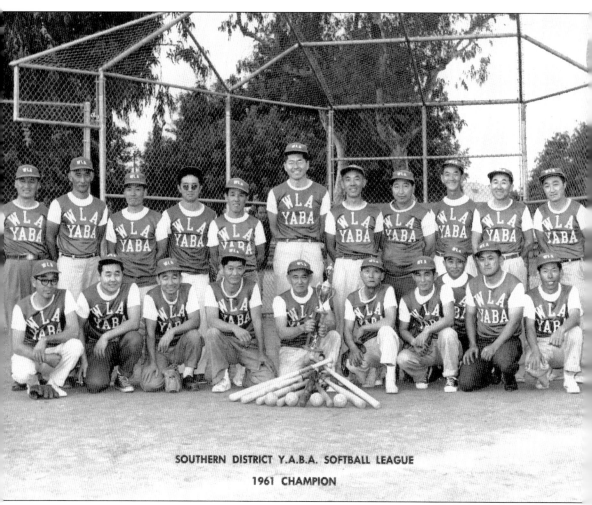

Pictured are the 1961 champions of the Southern District Young Adult Buddhist Association (YABA) softball league representing West Los Angeles Buddhist Temple. From left to right are (kneeling) Leo Tanaka, Jack Fujimoto, Eddie Fujino, Akira Nishimoto, Takeo Yabuta (holding trophy), Chiemi Yamaji, unidentified, Ken Kiyohiro, Kaz Shibata, and Mas Oshinomi; (standing) George Yamamoto, Art Hada, Tak Morimoto, Jiro Inoguch, unidentified, Harry Tashima, Mas Nakamura, David Akashi, Nori Takeuchi, David Uchida, and unidentified. (Courtesy Grace Fujimoto.)

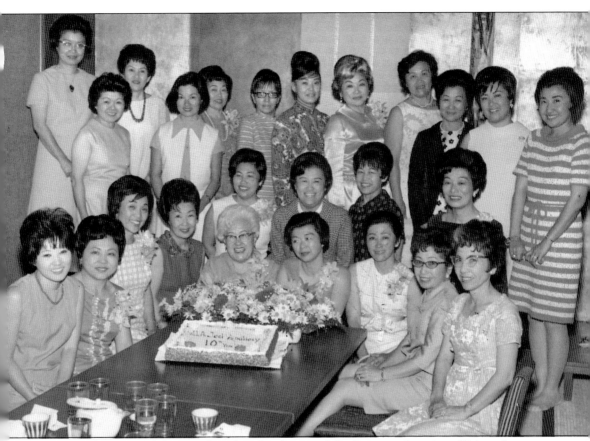

The auxiliary unit of the West Los Angeles chapter of the Japanese American Citizens League (JACL) held their 10th anniversary event in 1968 at the Century City Yamato Restaurant. Pictured, left to right, are (first row seated) Sako Asawa, Aiko Takeshita, Yuki Sato, Margaret Sakaniwa, Amy Nakashima, Chieko Inouye, Tayeko Isono, Rose Shiba, and Veronica Ohara; (second row seated) Suki Uyeno, Grace Kataoka, Haru Nakata, and Stella Kishi; (third row) Marian Susuki, Keiki Hankawa, unidentified, Elsie Uyematsu, Mabel Kitsuse, Mitsu Sonoda, unidentified, Toy Kanegai, Chiye Harada, Eiko Iwata, Ruth Watanabe, and Grace Nishizawa. (Courtesy Eiko Iwata, Jean Ushijima, and Haru Nakata.)

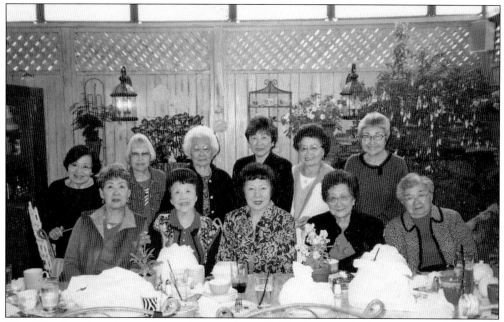
The West Los Angeles auxiliary chapter of the JACL photograph shows, from left to right, (first row) Nancy Sugimura, Mitzi Kurashita, Jean Ushijima, Eiko Iwata, and Chieko Inouye; (second row) Toshiko Nakashima, Haru Nakata, Hide Mochizuki, Sako Asawa, Fumi Yahiro, and Grace Nishizawa. (Courtesy Eiko Iwata and Jean Ushijima.)

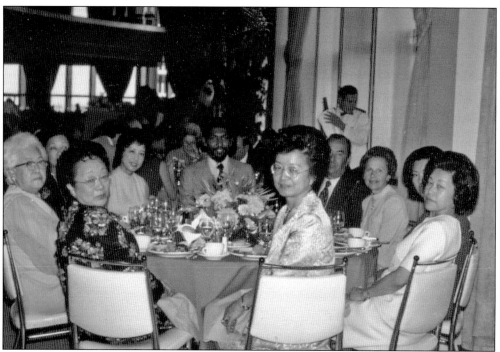
Pictured are several members of the West Los Angeles chapter of JACL who attended the reception for Emperor Hirohito of Japan on his 1975 visit to the United States. (Courtesy Arnold Maeda.)

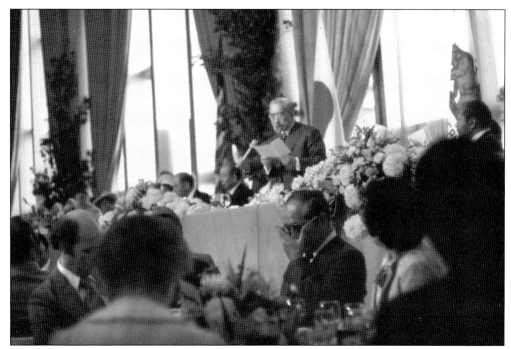

Emperor Hirohito of Japan addresses a welcome reception in Los Angeles on his visit to the United States in 1975. Several West Los Angeles chapter members attended. (Courtesy Arnold Maeda.)

Pictured is Joe Nagano, a chronicler of Sawtelle's Japantown activities for more than 60 years. As the first Nikkei employed by the Los Angeles City Department of Sanitation and well known for his work at the Hyperion Waste Treatment Plant, he has been photographing the changing landscape of Nikkei life in Japantown. He currently volunteers as a docent at the Japanese American National Museum. (Courtesy Joe Nagano.)

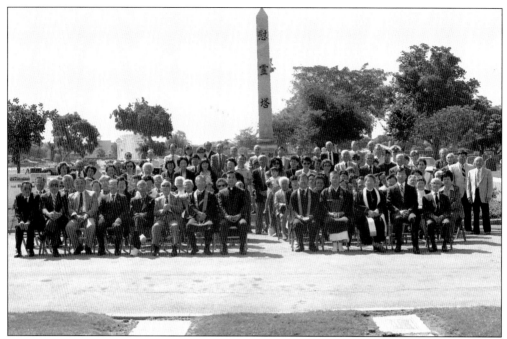

Community members from West Los Angeles join Santa Monica and Venice Nikkei on Memorial Day at the Woodlawn Cemetery Nikkei Monument for religious services. The monument represents the sacrifices made by the many Issei pioneers since the 1890s when they established their first colony, a fishing village in Santa Monica Canyon. (Courtesy George Oshimo.)

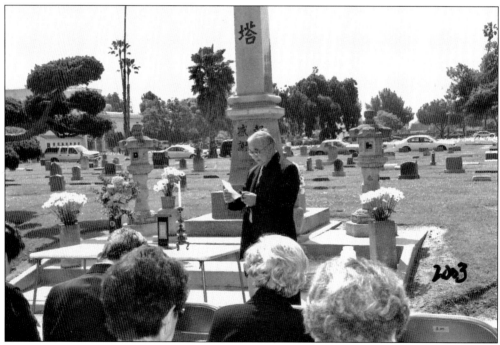

Jack Fujimoto chairs a Memorial Day service at the Japanese monument in Woodlawn Cemetery, Santa Monica. (Courtesy Grace Fujimoto.)

Yutaka Araki is providing community service with his lawn mower. He is known as a surf-fishing expert. (Courtesy George Oshimo.)

A garden maintenance group of volunteers, mainly from the Bay Cities Gardeners' Association, are pictured maintaining the beautifully landscaped garden at the West Los Angeles Buddhist Temple. (Courtesy George Oshimo.)

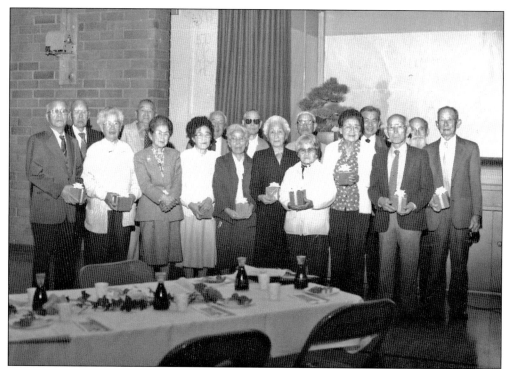

As part of the effort of Japantown to honor its seniors beyond 80 years of age, the Japanese Institute of Sawtelle sponsors a New Year's Day party to show their respect for the contributions of seniors to the Sawtelle community. (Courtesy George Oshimo.)

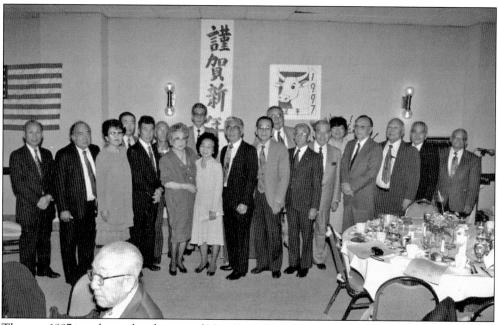

The year 1997 is welcomed at the annual New Year's Day party sponsored by the Japanese Institute of Sawtelle. (Courtesy George Oshimo.)

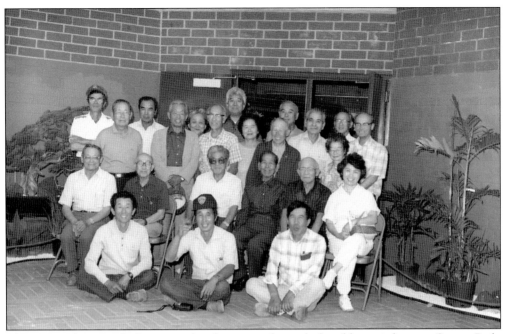

This group photograph shows people who set up the orchid and bonsai shows at Stoner Park. This is an annual event enjoyed by the Westside community. Tsukasa Mukai of the Bay Cities Gardeners' Association is one of the primary organizers and is seated in the center of the first row. In the second row, third from left, is George Yamaguchi, prominent bonsai expert and owner of Yamaguchi Bonsai Nursery. (Courtesy George Oshimo.)

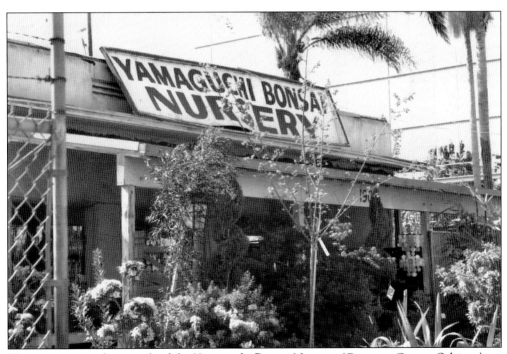

This is a current photograph of the Yamaguchi Bonsai Nursery. (Courtesy George Oshimo.)

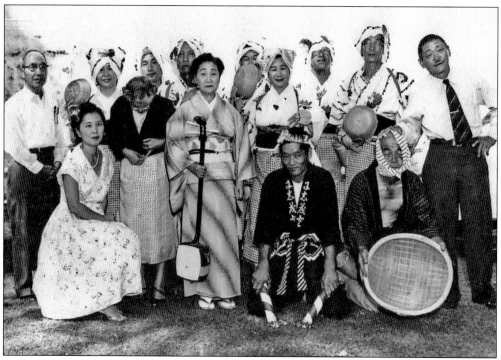

A 1960s entertainment group from Sawtelle's Japantown performed Japanese classical music, dance, and drama. (Courtesy Yoshinori Kubota.)

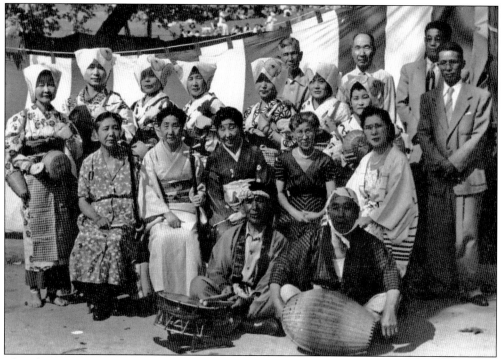

This photograph shows a Japantown entertainment group performing at the annual community picnic in the 1960s. (Courtesy Yoshinori Kubota.)

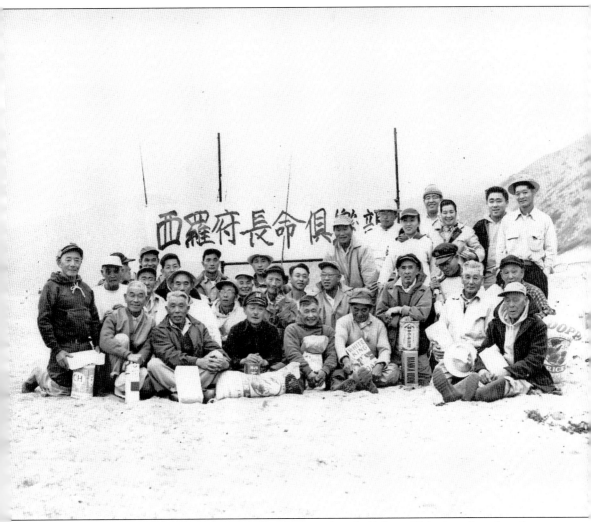

This group photograph shows members of the West Los Angeles Fishing Club. Awards and trophies were presented at these fishing derbies. The club was an integral part of the programs sponsored at JIS from the 1950s through 1980s. Jimmy Fukumoto and Susumu Naoye chaired many fishing derbies and were responsible for the many grades of fish and awarding prizes. In the 1980s, the fishing club declined in membership and eventually disbanded. Yet the tradition continues with Naoye's son, Mike Naoye, who owns and operates Bob's Sporting Goods, a fishing and tackle shop on Sawtelle Boulevard. (Courtesy Yoshinori Kubota and Mike Naoye.)

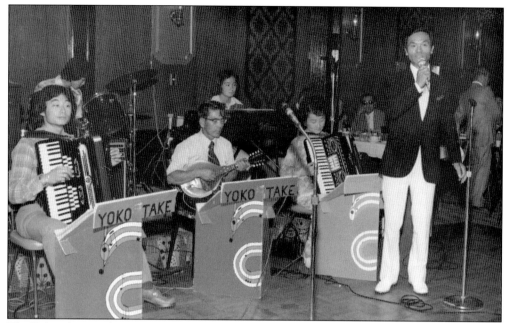

The Yokotake Family Band performed at many Japantown functions. They were very popular in Japanese American circles. Tak Nishi (the announcer with the microphone) continues to help musical groups in Japantown to this day. (Courtesy George Oshimo.)

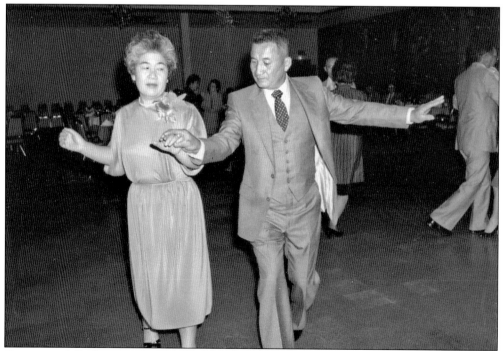

George and Ikuko Yamamoto show dance steps at a New Year's installation party for Bay Cities Gardeners' Association. Social dancing was a favorite pastime in Japantown. (Courtesy George Oshimo.)

Miyoko Shimahara is an active lady in Japantown. She initiated the 1994 campaign to import cherry blossom trees (*sakura*) from Japan and donated them to Stoner Park to beautify its premises. She also continues to this day to donate time and funds to the Japanese Institute of Sawtelle. For several years, she chaired the Cherry Blossom Festival in West Los Angeles. (Courtesy George Oshimo.)

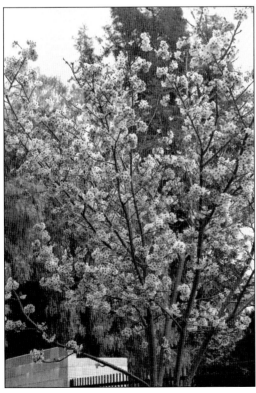

This photograph shows cherry blossoms at Stoner Park. (Courtesy Joe Nagano.)

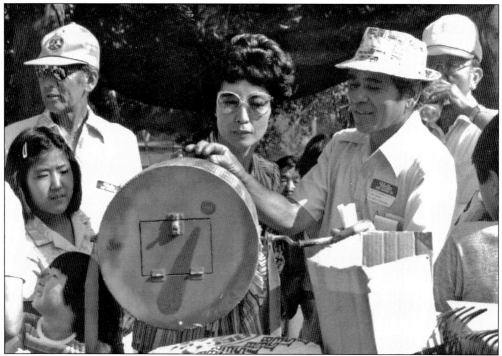
Harry Kobashigawa, who is assisted by Masako Okabayashi, cranks a raffle drum. This was a way to raise funds at a community picnic. (Courtesy George Oshimo.)

Fund-raising yard sales are examples of ways in which organizations raised money for Japantown groups such as Boy Scout Troop 39 and local churches. (Courtesy Grace Fujimoto.)

The annual ritual of making rice cakes (*mochi tsuki*) for the home is observed. This rice-pounding event takes place at the Ota residence. (Courtesy Joe Nagano and Mary Sata.)

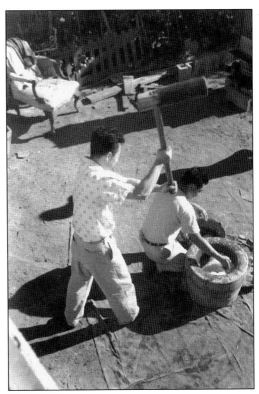

Japantown leaders are honored with plaques in appreciation of their support and work for the Japanese American community. (Courtesy George Oshimo.)

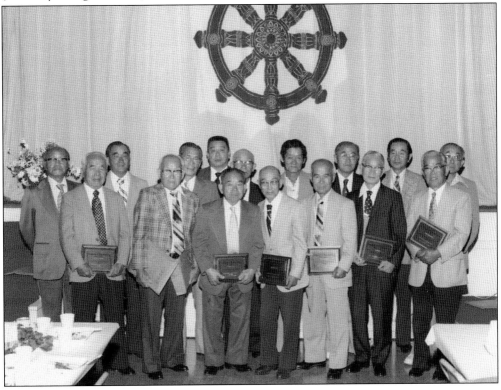

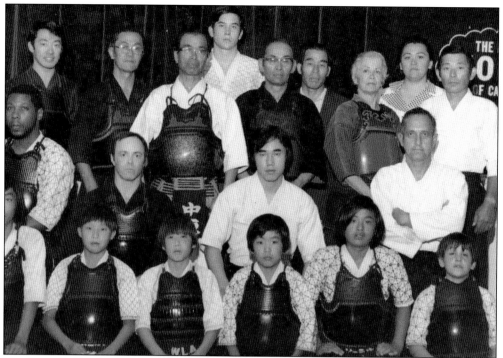

The Sawtelle Kendo Dojo continues to teach the martial art expressing the "way of the sword." Torataro Nakabara (third row, center, with hanging tassel) is the head master in this photograph taken in the 1950s. (Courtesy George Oshimo.)

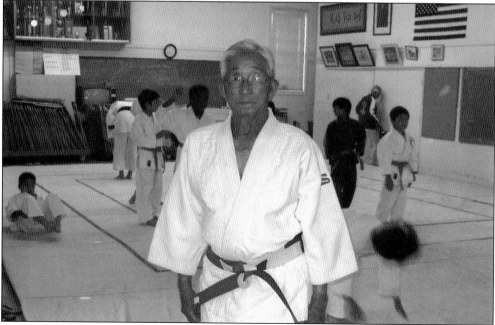

Haruo (Harry) Kaisaki is a seventh-degree black belt in Judo. At 92 years of age, he continues to visit the Sawtelle Judo Dojo at the Japanese Institute of Sawtelle to teach young students. (Courtesy Ida Kaisaki.)

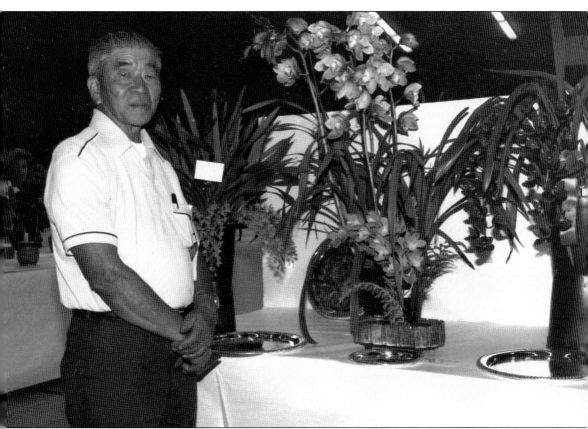
James Toya stands by his 1987 prize-winning cymbidium orchid. James was a prominent and noted hybridizer of cymbidium orchids. He was a member of the Bay Cities Gardeners' Association, frequently lecturing on orchid culture. (Courtesy BCGA.)

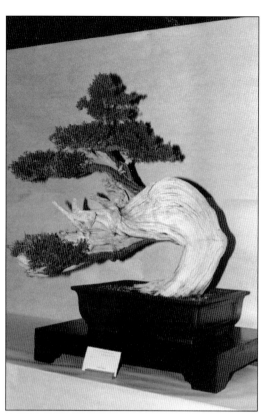

A 1990 juniper bonsai was judged the best. (Courtesy BCGA.)

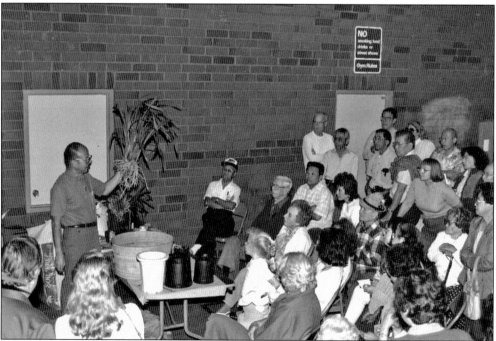

A member of the Bay Cities Gardeners' Association gives a lecture and demonstration at their annual Stoner Park orchid show in this photograph. (Courtesy BCGA.)

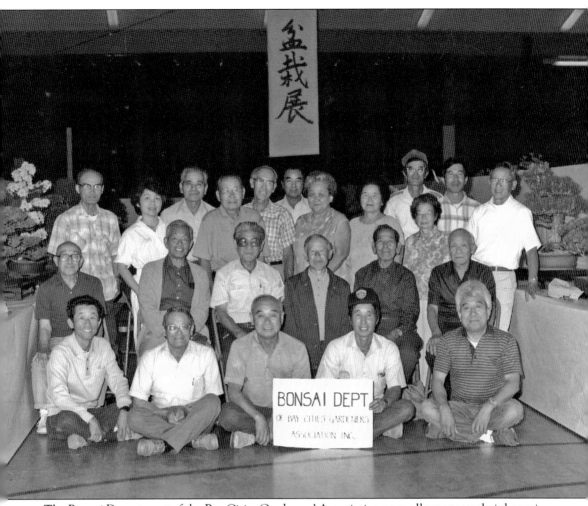

The Bonsai Department of the Bay Cities Gardeners' Association annually sponsors their bonsai exhibit to the public. Setting up the facilities for the two-day show requires the help of volunteers, such as those pictured. (Courtesy BCGA.)

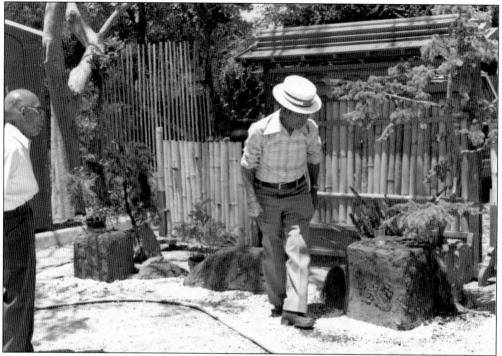

Bunsuke Shinto, landscape architect and craftsman, inspects the bamboo fence and garden that he designed and made. This shields the viewers from the toilet facilities at Rancho Park in West Los Angeles. (Courtesy BCGA.)

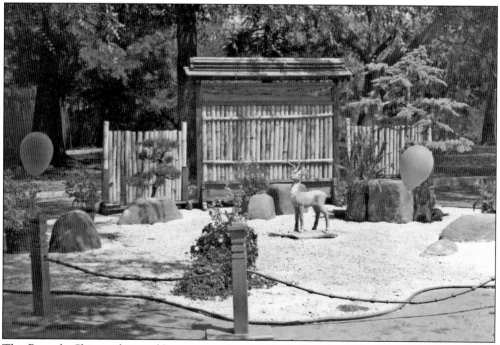

This Bunsuke Shinto–designed Japanese garden shields the Rancho Park toilet facilities. Members of the Bay Cities Gardeners' Association built the garden. (Courtesy BCGA.)

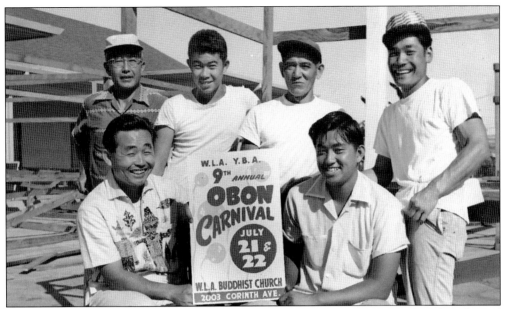

The West Los Angeles Young Buddhist Association (YBA) is preparing for the Obon festival in 1955. Pictured from left to right are (seated) Jack Fujimoto and Hank Iwamoto; (standing) Rev. Gikan Nishinaga (resident minister), Yosh Ichiho, Takeo Yabuta, and Tak Morimoto. (Courtesy Grace Fujimoto.)

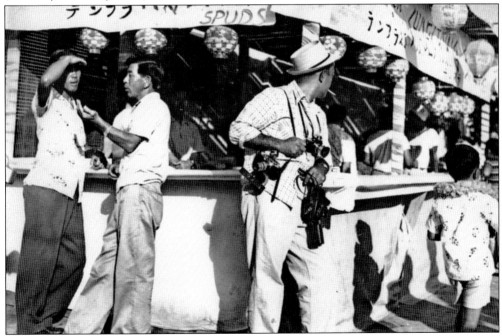

Observers at a 1950s Obon festival at the West Los Angeles Buddhist Temple were, from left to right, Mas Nakamura, Frank Sakahara, and Tom Ikkanda. Tom carries several cameras. He was one of the charter members of the West Los Angeles Buddhist Temple Camera Club along with Bunsuke Shinto, Tozo Yahata, David Akashi, and George Oshimo. (Courtesy Tom Ikkanda and George Oshima.)

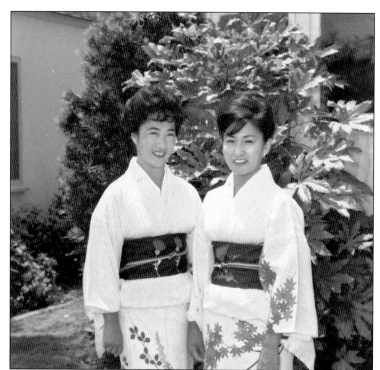

Yuki (left) and Grace Toya, sisters, wear the formal traditional kimono for Obon. (Courtesy Grace Fujimoto.)

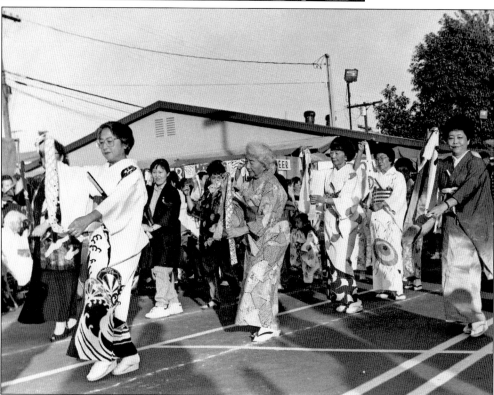

The Obon festival dancers are doing a folk dance requiring towels. (Courtesy George Oshimo.)

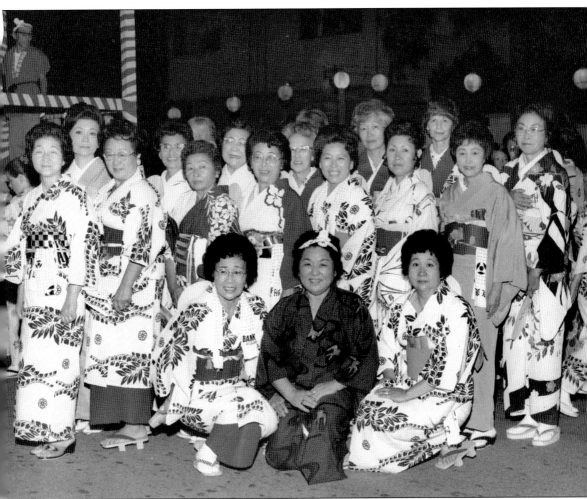

Obon festival dancers are smiling and congregating around Masaye Maruyama (wearing the black kimono). Annually the festival attracts large crowds, including many from the non-Nikkei public. Preparations for dances are done months ahead of the event. Teachers learn the new dances. Teachers then teach the general public the new and old dances for the upcoming Obon dance event. (Courtesy George Oshimo.)

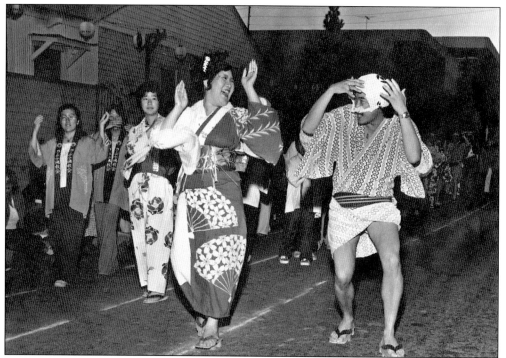
Greg Miyata, in his yukata robe, dances at the Obon festival in West Los Angeles. (Courtesy George Oshimo.)

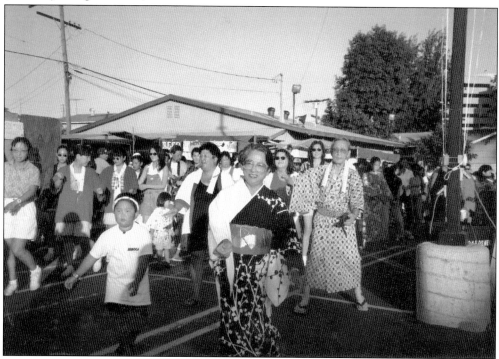
The 1998 Obon festival dancing shows Bill Sakurai following Grace Fujimoto. (Courtesy Grace Fujimoto.)

Five

THE CHANGING FACE OF JAPANTOWN

Since 1965, there has been a large inflow of Asian immigrants and non-Nikkei to Sawtelle's Japantown. Many shops still retain Japanese names; however, the previous owners are now replaced by immigrant Japanese or non-Nikkei and non-Sawtelle residents.

Many nurseries continue business because of the influx of customers or non-Nikkei professional gardeners. Many of the Japanese American gardeners have aged and therefore cut down their gardening routes considerably.

Several of the lawn mower shops such as Olympic Lawn Mower (Henry Shirasawa, owner), Baba's Mower Shop (Hiro Baba, owner), and George's Mowers (George Okamoto, proprietor) have moved or ceased business.

The Sawtelle Nikkei continue to cultivate their skills in bonsai, orchids, and the Japanese garden. The Bay Cities Gardeners' Association (BCGA) continues to provide a venue where gardeners meet, more often than not to discuss gardening skills as much as to publish their newsletter or to sing (karaoke style).

When the BCGA sponsors their annual bonsai festival, their annual orchid show, and their annual azalea (*satsuki*) exhibit, there is much public interest. Periodic ikebana (flower arrangement) shows and Japanese art exhibits by local Nikkei continue to have many viewers and are often featured by Sawtelle's Nikkei organizations.

Eateries continue to flourish; however, the tastes have changed from the typical Japanese family restaurant menu to the more specialized foods like curry, sushi, yakitori, shabu-shabu, and ramen. Even the gourmet restaurant, Sawtelle Kitchen, draws a considerable crowd.

Traditional Japanese foods are found in many local markets outside of Japantown; therefore, the old-line Japanese markets like Safe and Save Market and Granada Market from the 1950s find competition very difficult. Survival of markets like Sawtelle Food Market, which specialized in fish and tofu (locally made), was difficult. It was replaced by gift shops and restaurants.

The diversity of races, ethnicities, and cultures is showing its influence on the martial arts of kendo, judo, karate, iaido, and aikido. The diversity of shops along Sawtelle Boulevard is reflected in the various offerings and services provided to the Nikkei community.

The face of Sawtelle's Japantown continues to change by reflecting less of the Japanese immigrant experience of the 1920s and the Nikkei experience prior to and immediately after World War II. The Japanese American residents of Sawtelle have aged, and their offspring have ventured to opportunities elsewhere in a global economy, but in a typical year, many who grew up in Sawtelle return for a reunion with family and institutions such as JIS and the local churches or events such as Obon.

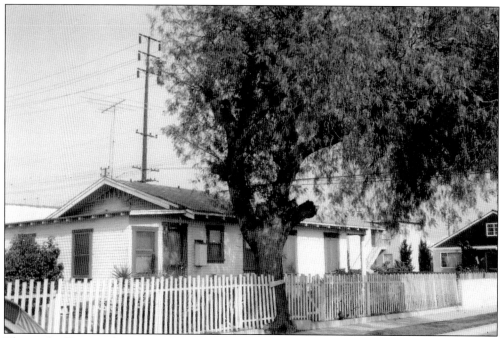

This is the Toya residence at 11331 Mississippi Avenue in the 1950s. This type of single-family dwelling was common in and near Japantown. With the influx of people to Japantown, higher density shelter was needed. With land values increasing in Japantown, many Japanese Americans sold their homes. (Courtesy Grace Fujimoto.)

This is 11331 Mississippi Avenue in 2005. The single-family dwelling above was replaced throughout Japantown with similar homes with much more space. The land- and space-density issues have caused Japantown to change immensely. (Courtesy Grace Fujimoto.)

This is a house at 1602 Granville Avenue in West Los Angeles. After being sold, it has resulted in apartments that are commonplace in much of West Los Angeles. (Courtesy Joe Nagano.)

These apartments at 1602 Granville Avenue are examples of how the housing density has changed and become commonplace in West Los Angeles. (Courtesy Joe Nagano.)

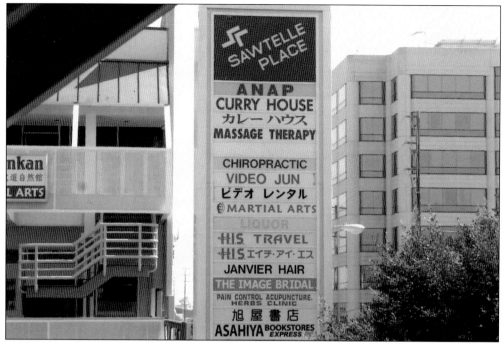

New Japantown features Sawtelle Plaza on the east side of Sawtelle Boulevard with its many small shops. This is illustrative of the changing face of Sawtelle's Japantown. Nurseries occupied these premises in the 1950s and 1960s. (Courtesy George Oshimo.)

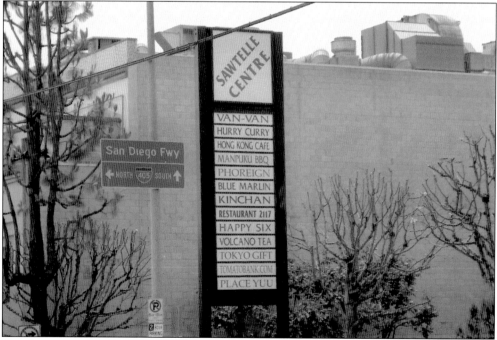

New Japantown features Sawtelle Centre on the west side of Sawtelle Boulevard with its many specialty eateries. Previously, in the 1950s and 1960s, automotive and lawn mower firms occupied this area. (Courtesy George Oshimo.)

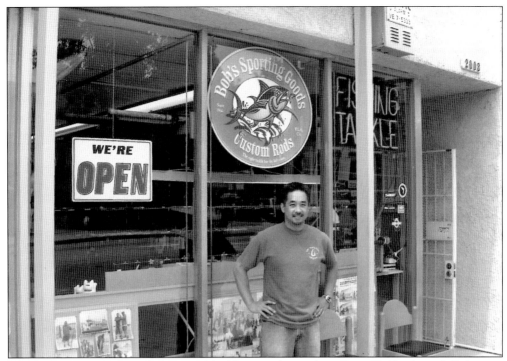

Bob's Sporting Goods with owner Mike Naoye is located on Sawtelle Boulevard. Fishing is not as popular now, but Mike continues his family tradition of being committed to Japantown. (Courtesy Grace Fujimoto.)

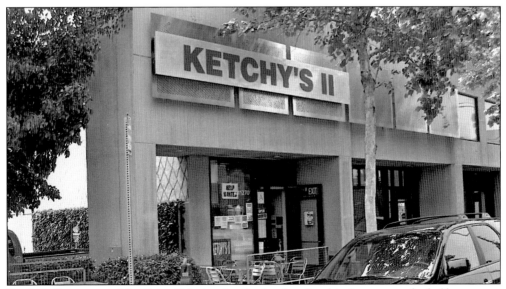

Ketchy's II is operated by Brian Fukai, a family that has lived in Japantown for half a century or more. Ketchie's was the lunch spot during the 1950s. To recapture this spirit, Brian opened Ketchy's II in November 2006. (Courtesy Grace Fujimoto.)

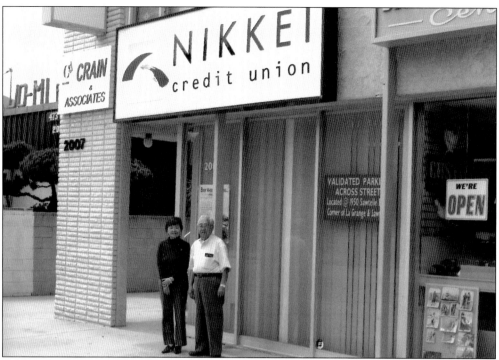
Nikkei Credit Union is new to Sawtelle's Japantown and offers alternative financial services. Sho Matsumi (right) and Eiko Tanaka are pictured. (Courtesy Grace Fujimoto.)

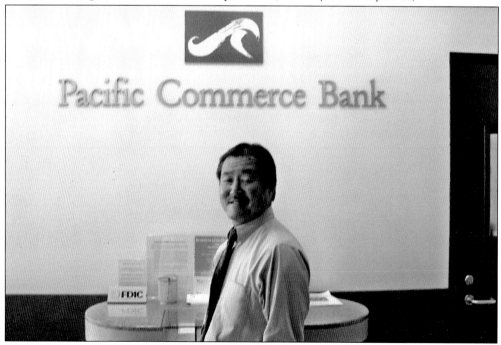
Pacific Commerce Bank is new to Sawtelle's Japantown, offering full-service banking to the Sawtelle Nikkei community. Ken Ota is manager of the West Los Angeles office. (Courtesy Grace Fujimoto.)

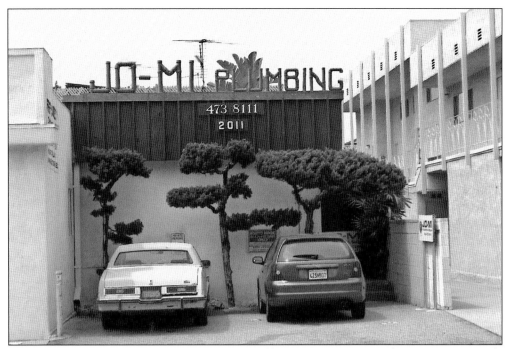

Jo-Mi Plumbing has been a mainstay in Sawtelle's Japantown since the 1940s. Joe Uyeda and Miki Matsumiya Uyeda built the business and transferred it to their son, Kelvin Uyeda. (Courtesy Jack Fujimoto.)

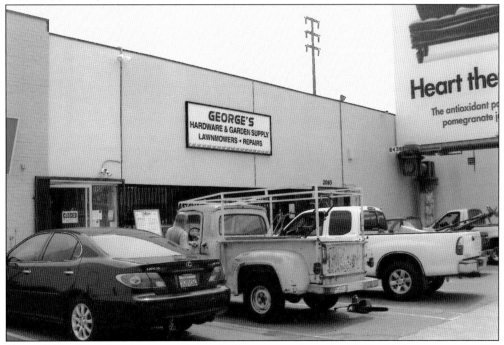

George's Hardware has been a mainstay in Japantown since the 1940s. Under new ownership and in a new location on Sawtelle Boulevard, it continues to serve the new Japantown. (Courtesy Jack Fujimoto.)

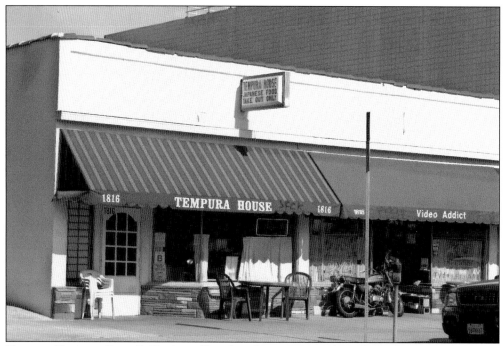

Tempura House on Sawtelle Boulevard has done business since the 1950s. It has been committed to the welfare of Japantown through its generous donations. (Courtesy George Oshimo.)

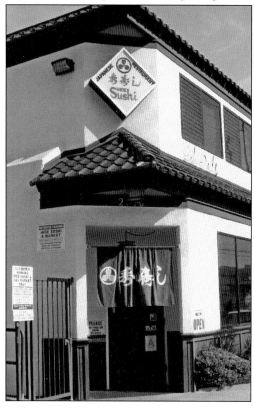

Hide Sushi is one of several fine eateries that are found on Sawtelle Boulevard. This contributes to the feeling that Sawtelle's Japantown is Little Osaka. (Courtesy George Oshimo.)

Bibliography

Bartolo, Kathy. *The Japanese of Sawtelle: A Study of Its People and Their Community* (oral history). UCLA Research Library, Special Collections Unit; March 15, 1975.

Cho, Rachel. *Sawtelle: The Cultivation of a Japanese American Community*. Unpublished manuscript.

Matsumoto, George Atsushi. *The Nikkei of Santa Monica and Sawtelle (West Los Angeles) in the Years from 1920 to 1942*. Unpublished manuscript; July 19, 2001.

Nanka Nikkei Voices. *Resettlement Years 1945–1955*. Los Angeles: Japanese American Historical Society of Southern California, 1998.

———. *Turning Points*. Los Angeles: Japanese American Historical Society of Southern California, 2002.

Matsueda, Tsukasa, Ed.D. *Issei: The Shadow Generation, Rooted in Japanese Values, Planted on American Soil*. San Francisco: Japanese Community and Cultural Center of Northern California, 2006.

Discover Thousands of Local History Books
Featuring Millions of Vintage Images

Arcadia Publishing, the leading local history publisher in the United States, is committed to making history accessible and meaningful through publishing books that celebrate and preserve the heritage of America's people and places.

Find more books like this at
www.arcadiapublishing.com

Search for your hometown history, your old stomping grounds, and even your favorite sports team.

Consistent with our mission to preserve history on a local level, this book was printed in South Carolina on American-made paper and manufactured entirely in the United States. Products carrying the accredited Forest Stewardship Council (FSC) label are printed on 100 percent FSC-certified paper.